IMAGES
of America

BIG SUR

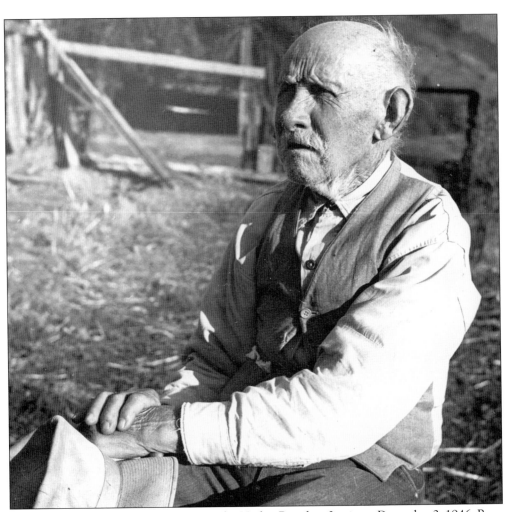

Pictured here is Wilber Judson Harlan at the Harlan Ranch at Lucia on December 2, 1946. Born in Rushville, Indiana, on December 14, 1860, Harlan lived with his family in Texas before he came west to Santa Cruz, California. He found a job at a local nursery where he met German immigrant Phillip Smith, and in 1885 the two of them came to the South Coast of Big Sur, seeking land. Harlan and Smith walked to the coast from the Salinas Valley, long before any roads served the Big Sur area. After staking his claim and building a cabin of hand-split redwood, Harlan courted and wed Ada Amanda Dani, daughter of nearby settler Gabriel Dani. Together the Harlans raised three daughters and seven sons, one of whom, Victor, died in his teens. As the family grew, Harlan built a larger home from redwood lumber produced by a sawmill that had been transported to the remote ranch by ship. Harlan died at Lucia on February 3, 1947. (Courtesy Stan Harlan.)

On the cover: "Cabin, Redwoods, and Pacific" is the title of the 1950s cover photo, which depicts the abandoned ranch house of Juan Bautista Avila, a son of Vicente Avila who settled along the San Antonio River, north of Mission San Antonio, in the 1860s. The Avila family is of Esselen and Rumsien Indian ancestry; Juan Bautista homesteaded near Lucia, receiving government title in 1892. His property is now part of the Immaculate Heart Hermitage, a Benedictine monastery. (Cole Weston photo from the Harbick Collection; courtesy California History Room, Monterey Public Library, and Edward Bernstein, executor of the estate of Cole Weston.)

IMAGES
of America

BIG SUR

Jeff Norman
Big Sur Historical Society

ARCADIA
PUBLISHING

Copyright © 2004 by Jeff Norman and the Big Sur Historical Society
ISBN 978-0-7385-2913-4

Published by Arcadia Publishing
Charleston, South Carolina

Printed in the United States of America

Library of Congress Catalog Card Number: 2004107761

For all general information contact Arcadia Publishing at:
Telephone 843-853-2070
Fax 843-853-0044
E-mail sales@arcadiapublishing.com
For customer service and orders:
Toll-Free 1-888-313-2665

Visit us on the Internet at www.arcadiapublishing.com

For more information on Big Sur history, contact the Big Sur Historical Society at 831-620-0541, or write us at PO Box 176, Big Sur, CA 93920. You may email us at bshs@mbay.net or visit us on the web at http://www.bigsurhistory.org.

An item found on page 57 of this book is from the Ava Helen and Linus Pauling Papers, Special Collections, Oregon State University. Quotations from *The Old Coyote of Big Sur* by Gui Mayo (Stonegarden Press, 1995) appear courtesy of the author.

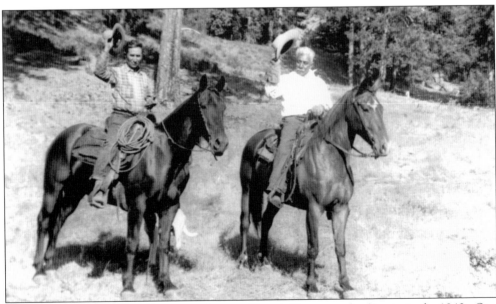

Steve Avila (left) and Tony Fontes are shown at French Camp, north of Lucia, in the 1940s. One of Juan Bautista Avila's sons, Steve was a well-known mountain lion hunter. His companion, Tony Fontes, a Salinan Indian, was a master horseman who worked on many of the local ranches. (Big Sur Historical Society.)

CONTENTS

ACKNOWLEDGMENTS

The author is deeply indebted to the following individuals who made their collections available. Without their kindness, generosity, and encouragement this book would not have been possible: Sylvia Trotter Anderson, Roy Bardin, Barbara Von Protz Chamberlain and Paul Von Protz, Jim Cox, Brook Elgie, Brook Ewoldsen, Helenka and John W. Frost, Erin Gafill, Lisa Gering and Ken Comello, Patrick Gileau, Norma Graham, Irene and Stan Harlan, Margaret Waters Harrell and Violet Waters King, Paul Herbert, Richard and Peggy Horan, Richard Jays, Jeannine Little Karnes and William Karnes, Martha Karstens, Alice Pfeiffer Kelch, James G. Kimball, Elizabeth Knerr, James R. Krenkel, Julian Lopez, the family of Horst Mayer, Constance McCoy, Jean Evans Murray, Jaci Pappas, Ruth and Franklin Peace, J.W. (Bill) Post III, Judy Smith, Walter Victorine, and Patricia and Sharon Ziel.

A number of archivists also assisted this project in every way, making the job much lighter. These are Daniel Bianchetta (Esalen Institute); Dennis Copeland (California History Room, Monterey Public Library); Pat Hathaway (California Views); Stephen Lawson and Chris Petersen (Oregon State University); Ray Melendez (Monterey County Free Libraries); Faye Messinger (Mayo Hayes O'Donnell Library); Kris Nelson Quist, Dave Schaechtele, and Rae Schwaderer (California Department of Parks and Recreation); Brenda Reed (USDA Forest Service); and Magnus Torén (Henry Miller Library).

Persons who contributed essential information and permissions are Linda Almen (Big Sur Branch, Monterey County Free Libraries); Ed Avila; Patrick Bailey; Edward Bernstein; Sharen Carey; Richard Costigan; Robert Cross; Martha Diehl; Ann Duwe and Deirdre Holbrook (Peninsula Open Space Trust); Kirk Gafill; Cheryl Goetz; Linda Grant; Boon Hughey; Soaring Jenkins-Starkey (Post Ranch Inn); Joe Johnson, Inga Labeaune, Debbie Reagan, and Chase Weaver (Monterey Public Library); Jan Jones; Hal Latta; Ranada Laughlin (California Department of Parks and Recreation); Kathleen M. Lee and Ann Anderson (Monterey County Supervisors office); Anne Lillmars (Friends of the Sea Otter); Kurt Loesch; Dani Sue Lopez; Chris Lorenc; Judy Marks; Gui Mayo; Alan McEwen; Paul Miller (Carmel *Pine Cone*); Shirley Whitney Moore; Willie Lopes Nelson; Andy Nusbaum (Esalen Institute); Linus C. Pauling Jr.; Alan Perlmutter; Denise Sallee; Ray Sanborn; Bette Sommerville; Jud and Joyce Vandevere; Marjorie Van Peski; Christine Ewoldsen Veach; Paula Walling; Matt Weston; Mary and Ken Wright; and Linda Yamane.

The technical assistance of several generous and patient locals was also greatly appreciated: Tracy Chesebrough; Tom Birmingham (Studio One, Big Sur); Christie Nanawa (Monterey History and Art Association); Gary Russell (GMR Custom Photographic Lab); and Tori Chesebrough, who gave so freely of her time.

In addition, board members of the Big Sur Historical Society were truly supportive, including Jeri Chesebrough, Dave Egbert, Norma Graham, Marty Hartman, Rosita Lopez, Antonia Nicklaus, Howard Strohn, and Mary Trotter.

Finally, the author wishes to extend personal thanks to those who helped in ways both tangible and intangible: Hannah Clayborn (editor, Arcadia); local historian and colleague Judith Goodman; Carol O'Neil (Central Coast Lighthouse Keepers), who suggested undertaking this task; friends and neighbors Eby Wold and Sam Goldeen; and, especially, Kathy MacKenzie.

INTRODUCTION

Big Sur is the name of the coastal landscape south of Carmel, in Monterey County, California. The rural region, which lacks any incorporated towns or villages, extends some 75 miles along the Pacific shore, to northern San Luis Obispo County (see map, pages 10–11). Strictly speaking, the north limit of the area is Malpaso Canyon in Carmel Highlands; the south limit, for the purposes of this book, is San Carpóforo Creek. With the ocean forming the western boundary, the Big Sur Coast can be said to extend inland as far as the limits of watersheds draining directly into the Pacific. This encompasses the steep coastal flank of the Santa Lucia mountain range, a defining factor of Big Sur country.

The term "Big Sur" is of mixed origin; *sur* means, in Spanish, "south." When Monterey was the capital of the Mexican province of Alta California in the early 19th century, the rough, inhospitable terrain to the south was referred to, simply, as *el sur*. Of the two rivers in the region, one was larger than the other; they were known as *El Río Grande del Sur* and *El Río Chiquito del Sur*. By the 1830s, U.S. citizens had entered the region and begun hybridizing the Spanish language with their own. Soon, *El Río Grande del Sur*, arguably the center of population then and now, was being called the Big Sur River; the renaming of the local post office to Big Sur Post Office in 1915 entrenched the nomenclature. Since then, the designation has expanded north and south to its present extent.

Before the Americans or Spanish claimed the region, Big Sur was the domain of three Native-American cultures. The Esselen people, about whom so little is known, are perhaps most identified with the area. Living in the rugged mountain country, Esselens spoke a Hokan language, which is in the same linguistic family as the Salinans, their neighbors immediately to the south. Salinan territory included portions of the Salinas Valley as well as the shore southward nearly to Morro Bay. To the north of the Esselens lived the Rumsien people, speakers of a Penutian language vastly different from Esselen and Salinan. The Rumsiens, a division of the larger Ohlone group, controlled the north Big Sur Coast, the Monterey Peninsula, and lower Carmel Valley. The descendants of these groups played an active part in the area's development throughout the 19th and 20th centuries, and continue to do so today.

With the establishment of the mission system in California in 1769, native ways of life were nearly obliterated. The padres desired to make these people members of the Spanish empire, with the resulting loss of countless lives and thousands of years of cultural heritage. By 1822, however, the Spanish were themselves supplanted by the revolutionary Mexican régime, and the vast crown lands of Alta California were subsequently distributed amongst the citizens of the area as land grants. Big Sur, a generally inappropriate region for cattle ranching, supported only three of these grants, two on the North Coast and one at the extreme south end.

The land grants were centers of the earliest known European activity on the Big Sur Coast. The grantees, however, were required to legally verify their ownership after California was admitted to the Union in 1850. Many of these former Mexican citizens, with a poor grasp of English and the U.S. legal system, lost their property. It is probably no coincidence that one of the successful claimants, Captain J.B.R. Cooper, had been born in England and enjoyed excellent political connections; in fact, his half-brother, Monterey resident Thomas Oliver Larkin, had been the U.S. consul to Alta California and had engaged in quite a bit of espionage for the U.S. government.

Americans were rather slow in the settlement of Big Sur, both because of the difficulty of access, and because of the distraction of the Gold Rush that began in 1849. The first Yankees on the coast seem to have been the remnants of the fur trappers who had nearly wiped out the beavers of the Rocky Mountains. These hardy mountaineers were at home in Big Sur, and proceeded to decimate the local population of sea otters, whose pelts were even more valuable than the beaver's. After California's entry into the United States, settlers took advantage of numerous laws enabling acquisition of unclaimed government land.

The Big Sur Coast developed into a community of hard-working ranchers, farmers, miners, and woodsmen. The area was reached by a system of narrow trails, or by ship, until entrepreneurs began building wagon and ox-cart roads in the mid-19th century. Even then, such roads did not penetrate far into the countryside, and could be wiped out in a single night of heavy rain. The establishment of more than a dozen "doghole ports" along the coast became nearly as important to local travel as the trail system. These landings, often short-lived, allowed the pioneers to export forest products, lime, and even livestock; the incoming boats might also offload precious goods that the locals couldn't manufacture themselves.

All this changed with the construction of Highway 1 in the early 20th century. Occupational patterns shifted from a subsistence economy based on resource exploitation to a scenery-based economy catering to the needs of visitors who came mostly to experience the incomparable views. With this influx also arrived artists, writers, musicians, and others who could turn the landscape into a livelihood in non-intrusive ways. Ranchers, miners, and lumberjacks can still be found in Big Sur, but they are becoming scarce indeed, and their lifestyle has become subordinate to the tourist industry. Nonetheless, the presence of these individuals is part of the place we call Big Sur today, and reminds us that the human element can achieve balance with the physical setting that sustains visitor and resident alike.

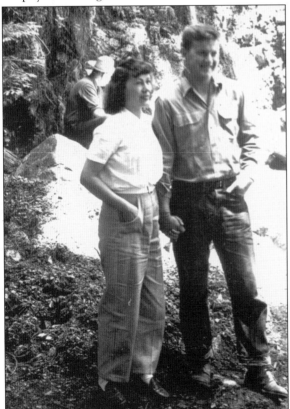

Irene and Stan Harlan are shown at the Harlan Ranch in May 1949. Stan, youngest of the three sons of George A. Harlan, wed Irene Marus on March 1, 1948. Irene and Stan Harlan are outstanding conservators of the history of Big Sur's South Coast. (Courtesy Stan Harlan.)

One

THE PIONEERS

This cabin, which once stood at the mouth of the Little Sur River, may have been built by Edward Gayetty, who acquired the land by cash sale from the U.S. government in 1891. The Gayetty brothers, Joseph and Edward, established an abalone cannery south of Point Lobos, which they ran from 1900 to 1902 before moving the operation to Cayucos in San Luis Obispo County. The first modern-era landowners in Big Sur were the Mexican land grantees; after statehood, Californians made use of four principal U.S. land entitlements. The Preemption Act of 1841 allowed the purchase of land unclaimed by another; this "cash sale" required paying the government $1.25 per acre, for up to 160 acres. The Homestead Act of 1862 enabled pioneers to acquire 160 acres after showing that the land could support them. Patent was given after five years of occupancy and the payment of a paltry filing fee. Other federal laws, such as the 1872 Mining Act and the 1878 Timber and Stone Act, were also used by Big Sur settlers to gain property. (Sibyl Anikeyev photo, 1940, Northern California Art Project, Works Projects Administration; courtesy California History Room, Monterey Public Library.)

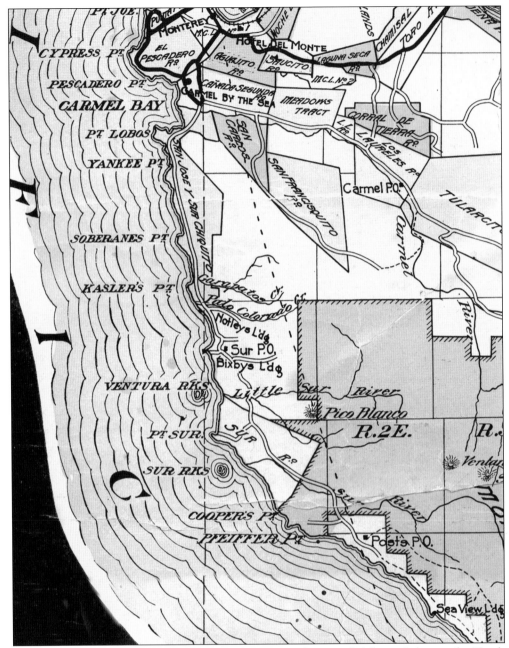

This image of a portion of the 1908 "Map of Monterey County, California," depicts the North Coast of Big Sur, the Carmel Highlands area, and the Monterey Peninsula. Malpaso Creek, the northern limit of the Big Sur Coast, is immediately south of Yankee Point. The boundaries of many Mexican-era land grants are shown, including the two located on the north Big Sur Coast: Rancho San José y Sur Chiquito and Rancho El Sur. The terminus of the County Road, accessible for wagon traffic, is shown at the Castro Ranch; beyond, travel by land was on horseback or by foot. (Map by Monterey County Surveyor Lou G. Hare; courtesy California History Room, Monterey Public Library.)

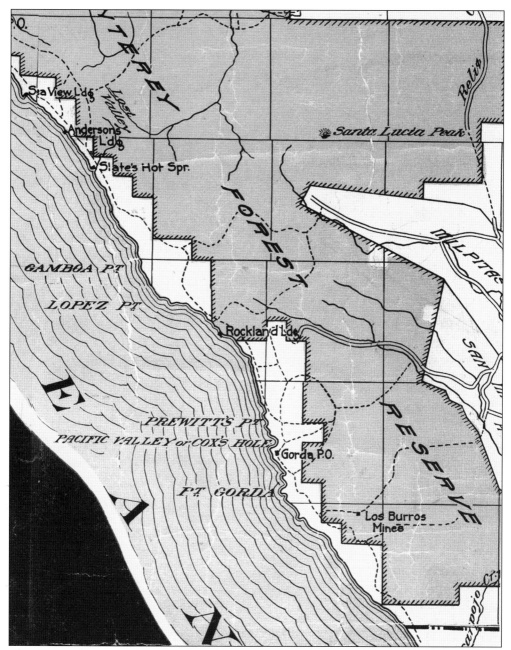

This image of a portion of the 1908 "Map of Monterey County, California," shows the South Coast of Big Sur; Lucia is located between Lopez Point and Rockland Landing. This region lacked road access until the construction of Highway 1 was begun in 1922. Travel in the early days was by trail only, shown as dashed lines on the map, or by coastwise vessels that called at doghole ports such as Seaview and Anderson landings. A few isolated areas, such as Pacific Valley, had wagon roads, but at those locations, the wagons themselves were unloaded from the ships and used only in the immediate area. The Montery–San Luis Obispo county line is shown at the bottom of the map, where it crosses San Carpóforo Creek (shown as Carpojo Cr.). (Map by Monterey County Surveyor Lou G. Hare; courtesy California History Room, Monterey Public Library.)

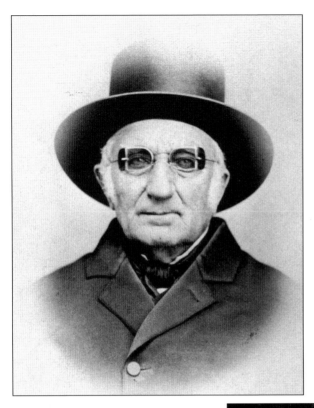

John Rogers Cooper (1791–1872), depicted here in the late 1860s, was born in England. Cooper came to the United States around 1800 with his mother, and was engaged in merchant shipping. He crossed the Pacific many times, shipping sea otter skins from California to China and the Philippines via Hawai'i. Capt. Cooper first sailed into Monterey Bay in 1823, and in 1826 took up residence in Monterey, then the capital of Mexico's Alta California. Cooper converted to Catholicism and was baptized Juan Bautista Rogers Cooper. Awarded several Mexican land grants, he took possession of Rancho El Sur, which included today's Andrew Molera State Park, in 1840. (Courtesy Mayo Hayes O'Donnell Library and the Society of California Pioneers.)

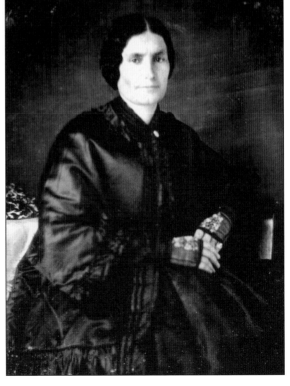

After his Roman Catholic baptism, Cooper was free to marry María Geronima Encarnación Vallejo, born March 24, 1809 in Monterey. Encarnación was the daughter of Ignacio Vallejo, a distinguished sergeant of the Spanish Army, and her brother, Mariano Vallejo, was a noted citizen and general of the Mexican Army during its war with the United States, 1846–1848. The town of Vallejo in Northern California is named for Mariano. Encarnación Vallejo de Cooper died in San Francisco on January 15, 1902. (Courtesy Mayo Hayes O'Donnell Library and the Society of California Pioneers.)

Eusebio Molera, a native of Vich, Spain, graduated from the Spanish Academy of Royal Engineers in 1868. After coming to the United States, he became a prominent architect and engineer, and may have been involved in the siting of Point Sur Lightstation, built adjacent to Rancho El Sur in 1889. Eusebio wed Amelia Cooper, second daughter of J.B.R. and Encarnación, in 1875. Molera shared management of Rancho El Sur with his brother-in-law, John Bautista Henry Cooper. Among other innovations on the ranch, Molera experimented (unsuccessfully) with the cross-breeding of cattle with the American bison, or buffalo. (Courtesy Mayo Hayes O'Donnell Library and the Society of California Pioneers.)

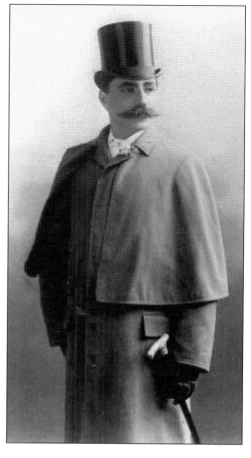

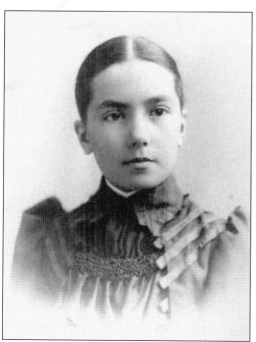

Frances Molera (1879–1968), daughter of Eusebio and Amelia Molera, is seen here in the 1890s. She lived for many years in the Cooper family home in Monterey, now known as the Cooper-Molera Adobe and part of Monterey State Historic Park. Frances, who inherited the southern half of her grandfather's Rancho El Sur, bequeathed the 2,200 acres west of Highway 1 to The Nature Conservancy. This land was later acquired by the State of California and opened to the public as Andrew Molera State Park, named in honor of her brother. The remainder of Frances Molera's property, on the east side of Highway 1, was added to the park shortly thereafter. She willed the Cooper-Molera Adobe to the National Trust for Historic Preservation. (Courtesy Mayo Hayes O'Donnell Library and the Society of California Pioneers.)

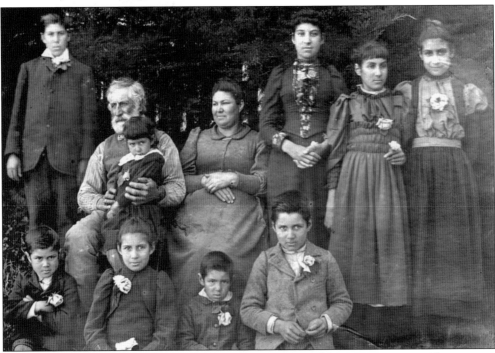

Shown from left to right are María Josefa Estrada de Ábrego, María Buelna, Agustias Ábrego Webb, Clara Buelna, and José Ábrego (husband of María Josefa) on the patio of their home in Monterey. In 1841 María Josefa purchased Rancho San José y Sur Chiquito, extending from the Carmel River to Palo Colorado Canyon. It's said that María Josefa lost the land in a card game with several Presidio of Monterey soldiers. Perhaps it was José, an inveterate gambler, who lost it, and that María, who held the land in proxy for her husband, effected the legal transfer. This and other factors clouded the title to the ranch, which was finally confirmed by the U.S. government in 1888 after 38 years of litigation. None of the Mexican petitioners' claims were recognized. (Courtesy California History Room, Monterey Public Library.)

David Castro, one of the squatters on Rancho San José y Sur Chiquito prior to its confirmation, is shown here many years later with his family. Castro bought the rights to William Brainard Post's claim, located in today's Garrapata State Park, in 1866, after Post gave up on ever owning the land. A year later Castro sold out to Esequiél Soberanes, later moving to the canyon that bears his name, site of today's Deetjen's Big Sur Inn. In 1877 Castro married Amada Vasquez, whose father at one time owned the ranch at Palo Colorado. Seen in this c. 1896 picture, from left to right, are (front row) Rojelio, Cary, Tony, and Dan; (back row) Alex, David (holding Rebecca), Amada, Lorena, Minnie, and Alvera. (Frank Trotter Collection, Big Sur Historical Society.)

Anselma Onesimo married William Brainard Post in 1850. Anselma was of Rumsien Indian descent, and it has been said that her ancestors helped Junípero Serra build the Carmel Mission. She was born in 1828 in Carmel Valley; her parents were María Ygnacia (born in 1800) and Antonio Onesimo (1796–1860). Anselma's sister, Loreta, was married to James Meadows, an English immigrant to Mexican California who was given a productive land grant in Carmel Valley. It was there that Post met his future wife. Anselma Post died in 1902. (Courtesy Franklin Peace and Post Ranch Inn.)

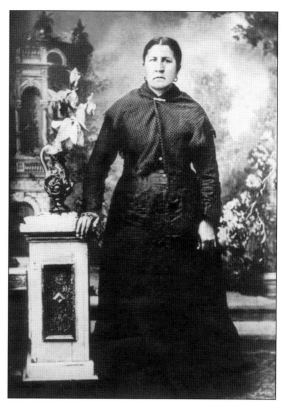

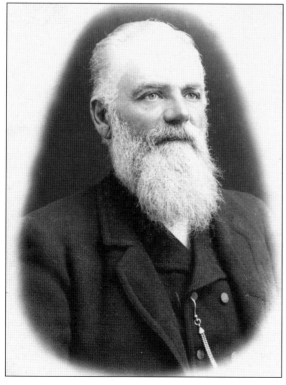

William Brainard Post (1830–1908) was born in Connecticut and arrived in Monterey in 1848. After his marriage to Anselma, Post farmed in the lower Carmel Valley, and in 1858 took up his claim at Soberanes Canyon. Post was well known for his bear hunting, and also pursued deer for hides and meat, which he sold in Monterey. In 1866, at the time he sold his claim to David Castro, Post built a small cabin south of the Big Sur River, along today's Post Creek. He then worked at Moss Landing and operated a butcher shop in Castroville. In 1877 Post and his family moved back to Big Sur. Post was active in community affairs and successfully lobbied the County of Monterey to extend the County Road south to his ranch and beyond to the Castro place. (Courtesy Franklin Peace.)

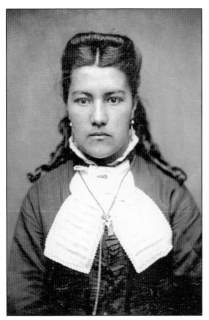

Ellen, the first child of Anselma and W.B. Post, was born on October 31, 1851 and is seen here in an original tintype from the 1870s. Ellen Post was wed to Edward Grimes on Christmas Day, 1879 at the ranch of Joseph and Lola Soberanes Gregg in lower Carmel Valley. On that occasion the first Christmas tree in the Carmel area was unveiled, with W.B. Post playing the role of Santa Claus. Ellen had three children with Edward: Isabelle (born in 1880), Edward Robert (born in 1888), and Ellen (born in 1891). (Courtesy Norma Graham.)

In his later years, W.B. Post built several houses on Belden Street in Monterey for himself and his extended family. This picture was taken at one of these homes and shows, from left to right, Isabel Meadows and Post's two daughters, Mary Ann de la Torre and Ellen Grimes. Mary wed José de la Torre, a member of an old Spanish family of Monterey, and together they homesteaded in Torre Canyon, about eight miles south of the Post Ranch. Ellen and Mary's cousin, Isabel, daughter of James and Loreta Meadows, was familiar with the Rumsien language and was the last person known to speak Esselen, the language of the people who lived in the coastal mountains between the Rumsien and Salinan cultures. (Courtesy Franklin Peace.)

Edward Grimes was born in Norfolk, England, on May 24, 1854. He came to work at the ranch of his uncle, James Meadows, in 1875. In 1885 he and his wife, Ellen, homesteaded in Grimes Canyon, some five miles south of Post's. Sam Trotter, the noted woodsman and builder, visited the Grimes place in 1893. In his memoirs Trotter wrote fondly of their ranch, which was "so neat and tidy and homelike I hated to leave." In later years the Grimeses moved to Belden Street in Monterey, where Edward worked as a teamster. (Courtesy Franklin Peace.)

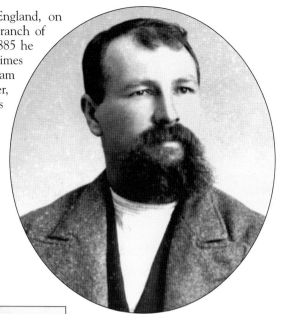

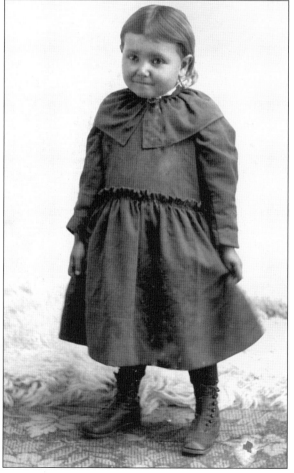

Ellen Grimes, the youngest daughter of Edward and Ellen Post Grimes, was born at the Post Ranch, as were her brother and sister. Ellen vividly recalled the narrow County Trail, also called the Lower Coast Trail; one of her earliest memories was of her father placing her on a pillow in front of him on the saddle as they rode horseback. In this picture, taken in 1896, a four-year-old Ellen is wearing a new pair of shoes. In 1917 she married Robert F. Peace and later lived in Pacific Grove. Her son, Franklin Peace, is a well-known beekeeper residing in Carmel Valley. (Courtesy Franklin Peace.)

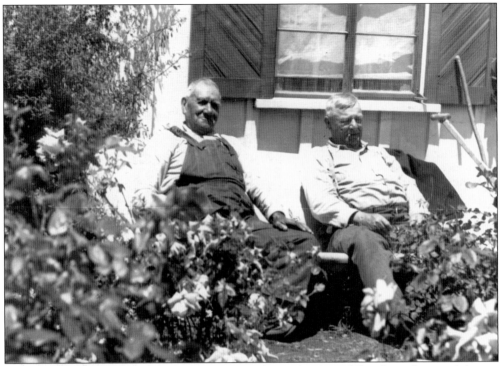

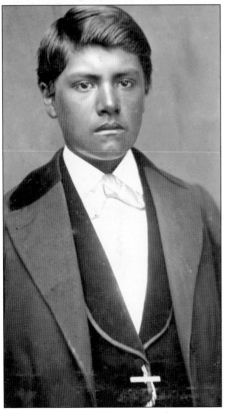

Frank Post (1859–1953) is shown here with his brother-in-law, Peter Nelson (right). Post, the eldest son of Anselma and W.B., married Annie Pate, whose sister Ida wed Peter Nelson, an assistant lighthouse keeper at Point Sur. Nelson was born in Germany in 1871; his sister Catherine was married to head lighthouse keeper John Ingersoll. The two old-timers are pictured here, probably in the 1940s, enjoying the view from Loma Vista Inn, built by Frank's daughter and son-in-law Alice and Steve Jaeger. This restaurant and nursery operation continues to be one of Big Sur's most pleasant venues for locals and visitors alike. (Courtesy Norma Graham.)

A much younger Frank Post is seen in this tintype, probably from the 1870s. Charles Francis Post was born at his family's ranch along what is now called Soberanes Creek in Garrapata State Park. In those early days before the Soberanes family resided there, the place was called La Lobera, due to the presence of sea lions (known to the Spanish as *lobos marinos*, or "sea wolves") on the offshore rocks. Frank Post homesteaded the site of today's Nepenthe restaurant, later trading the land with his father in return for the property on which Loma Vista Inn now stands. (Courtesy Franklin Peace.)

Annie Pate was the wife of Frank Post. Her father, Edmond, had a ranch along a branch of the Little Sur River known as Pates Fork. This property was traversed by what is now called the Old Coast Road, the route advocated by her future father-in-law, William Brainard Post. In 1886 funds from the County of Monterey were allocated for its construction. Since the county partly paid for its building and maintenance and today is fully responsible for its upkeep, some old-timers still use the name County Road for this unsurfaced route running some 10.5 miles from Bixby Bridge south to Andrew Molera State Park. (Courtesy Norma Graham.)

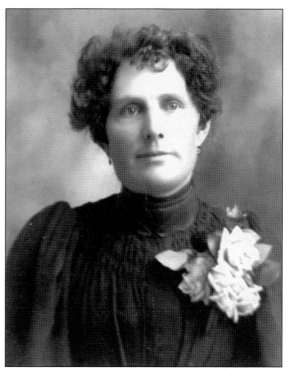

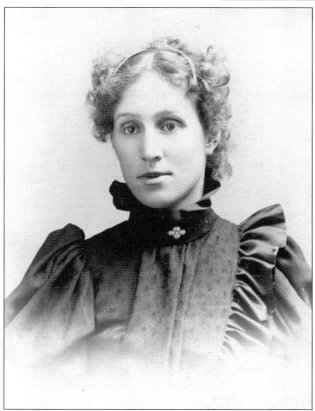

Ida Pate Nelson was born in March 1876, and was living at Point Sur Lightstation with her husband, Peter, in 1900. Their grandson, Don Nelson, tells the story of his grandparents' meeting. It seems that Ida's father, Edmond, raised hogs on his ranch near the lighthouse. One day Peter happened to see Ida riding a pet pig over the hill from her parents' place. It was love at first sight, and the couple wed in 1895. Later the Nelsons were stationed at Point Pinos in Pacific Grove, the oldest continuously operating lighthouse on the Pacific shore. (Courtesy Norma Graham.)

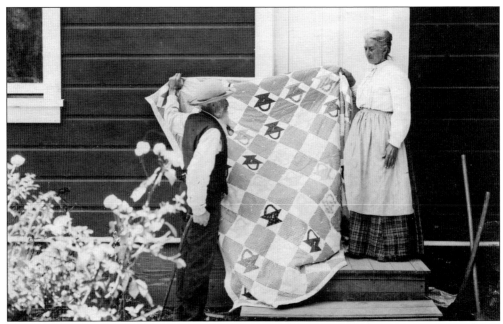

Michael and Barbara Pfeiffer are shown with a quilt, made by Barbara, in front of their home in Sycamore Canyon, *c*. 1910. The Pfeiffers settled in Big Sur in 1869, arriving near Sycamore Canyon on October 14 of that year. They had traveled the meager trail from Monterey bound for Pacific Valley, some 60 miles to the south. The Pfeiffers had their four children with them (four more would be born in Big Sur), and were dismayed with the difficulty of traveling along the coast. One of the boys was ill, so they decided to wait out the winter and build a lean-to as temporary shelter. Next spring, having discovered that the land they were occupying could support them, the Pfeiffers decided to stay. Their descendants are still here. (Courtesy Ewoldsen family.)

The Pfeiffer home, built by Michael and Barbara's son, John Martin Pfeiffer, was tucked into Bear Killed Two Calves Creek, a tributary of Sycamore Creek west of Highway 1 and the Big Sur Valley. The small stream received the name after an event that seriously impacted the struggling family in the days when the now-extinct California grizzly bear was the top predator on the coast. Sycamore Creek enters the Pacific Ocean at Pfeiffer Beach, which is open to the public and managed by the U.S. Forest Service. The Pfeiffer Ranch, seen here *c*. 1910, was sold many years ago, and the surrounding hills are now home to many modern inhabitants of Big Sur. (Courtesy Sylvia Trotter Anderson.)

Michael Pfeiffer (1832–1917) was born in Illinois and came to California in 1858 to join his brothers, Joseph and Alexander. After an unsuccessful try at gold mining, Michael and Barbara (1843–1926), born in the Alsace-Lorraine, together with his brothers, raised wheat in Northern California. Michael and Barbara then moved to Tomales Bay and leased a dairy, moving when their rent was raised. Land in Big Sur, they discovered, could be settled for little more than the $5 fee required to file a homestead claim. The couple, seen here c. 1916, lived together on their ranch for a full 58 years. (Courtesy Alice Pfeiffer Kelch.)

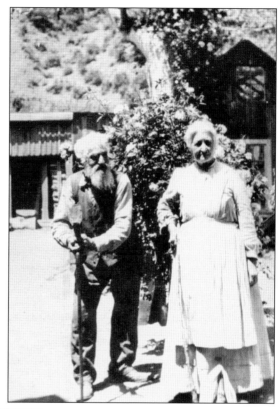

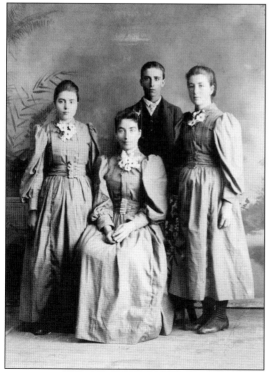

Four of Michael and Barbara Pfeiffer's children are shown in this c. 1899 photo. From left to right are Flora Catherine, Julia Cecilia, Frank Anthony, and Adelaide Barbara. Julia was just 11 months old when her parents brought her to Big Sur; she became one of the coast's best-loved residents. Adelaide, known as Lida, married the legendary Sam Trotter. Flora Catherine, called Kate, later wed Alvin Dani, brother of Ada Amanda Dani (Wilber Harlan's wife). Frank Pfeiffer was killed in 1934 in a landslide at Hurricane Point while working on the construction of Highway 1. (Courtesy Alice Pfeiffer Kelch.)

Alvin and Kate Dani are pictured on the steps of her parents' home in Sycamore Canyon in the late 1940s. Alvin and Kate were married on December 31, 1902; he had previously been married to Kate's sister Mary Ellen, who died in 1900. Alvin had earlier homesteaded a claim in Limekiln Canyon just south of his parents' ranch and later lived with Mary Ellen at Burns Creek in the old James Anderson house. At the time of Mary Ellen's death they were living at their ranch at Dani Ridge, on Pico Blanco between the forks of the Little Sur. Alvin died in 1949 and Kate passed away in 1961. (Big Sur Historical Society photo by Harry Hartmann.)

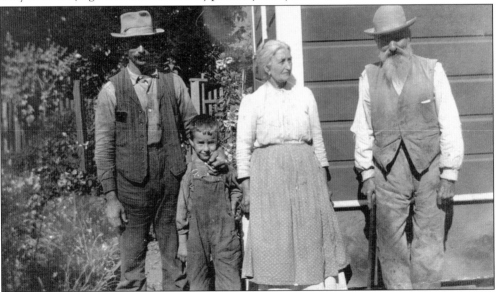

Michael and Barbara Pfeiffer's son William Nicholas (far left) is shown with his parents and his son, Joseph Alexander, at the Pfeiffer home, c. 1916. William Pfeiffer was born in Big Sur on September 29, 1873, and his son, Joe, on August 26, 1910. Joe and his siblings were orphaned in 1920 when their parents died of influenza. After graduation from Monterey High School in 1928, Joe wed Mary Breiling Koch. Together they were caretakers at Saddle Rock Ranch in McWay Canyon, now the location of Julia Pfeiffer Burns State Park, named for Joe Pfeiffer's aunt, Julia Cecilia Pfeiffer Burns. (Courtesy Alice Pfeiffer Kelch.)

Kate Dani raised the three children her sister had with Alvin: Maryetta DeClarence, Adelaide Electa, and Alvina. Kate also bore six children with Alvin: Katherine, Albert, Stanley, Donald, Margaret, and Helen. Here, c. 1909, Electa stands behind, from left to right, Katherine, Stanley, Alvina (holding Donald), and Albert. For many years Stanley operated a dance hall along the Big Sur River on today's Fernwood Resort property. He was also foreman of the Molera Ranch, now Andrew Molera State Park. Electa married Corbett Grimes and operated a cattle ranch at Palo Colorado (named by the Spanish for the presence of coast redwoods, *palos colorados*). Margaret married Tony Brazil of Bixby Canyon, and her sister Katherine was wed to Tony's brother, John. Albert's wife, Neva, was the stepdaughter of Oscar Pfeiffer. (Frank Trotter Collection, Big Sur Historical Society.)

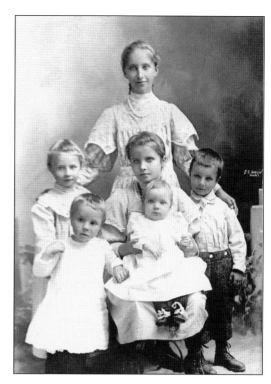

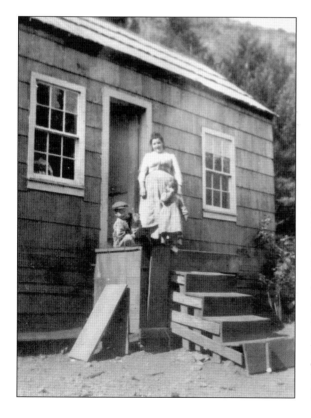

Alice Amelia Dani Pfeiffer is shown with two of her children, Oscar Sebastian, born in 1903 (left), and Wilhelmina Clementine, born in 1904. They are pictured at the home her husband William built on the hillside north of Sycamore Creek. William and Alice died of the flu within days of one another—he on March 8 and she on March 10, 1920. They are buried at the Pfeiffer family cemetery in Big Sur. Oscar, who died in 1984, is remembered as an outstanding storyteller. Wilhelmina, known as Mina, was married to George Breiling, brother of Joe Pfeiffer's wife, Mary. (Courtesy Alice Pfeiffer Kelch.)

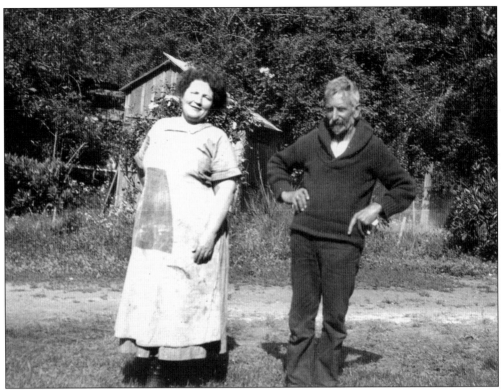

John M. Pfeiffer (1862–1941) married Zulema Florence Swetnam (1871–1958) in April 1902. Florence, born in Kentucky, traveled west with her parents, Ellen Jane and Isaac Newton Swetnam. The Swetnams settled first on the North Fork of the Little Sur, then in Garrapata Canyon, and finally at the mouth of Palo Colorado Canyon. For some 30 years Florence was the postmaster of the three post offices located in the Big Sur Valley area, and also operated Pfeiffer's Ranch Resort at the location of today's Pfeiffer Big Sur State Park. John was active in cattle ranching and beekeeping, and was an authority on local natural history. (Courtesy Ewoldsen family.)

Florence and John's daughter, Esther Julia Pfeiffer (1904–2000), married German immigrant Hans Ewoldsen in 1931. Esther followed in her mother's footsteps as postmaster of the Big Sur Post Office. Esther and Hans had three children—Ernst, Hans Martin, and Christine—and for many years were caretakers at Saddle Rock Ranch for Helen and Lathrop Brown. They later built a place on land Esther's father gave her, "The Knoll," high above the Big Sur Valley. Esther, an expert on the native flora as well as cultivated plants, was also an astute observer of Big Sur's history. (Courtesy Ewoldsen family.)

Hans Ewoldsen (1902–1994) is pictured standing in "The Window" (in Spanish, *la ventana*), *c.* 1930. On this expedition Hans and his future wife, Esther, made the trek with John Pfeiffer. Hans, a native of the level terrain of northern Germany, took a lifelong delight in the mountains of Big Sur. While working for the Browns, he maintained the many horse and foot trails in the area between Partington Canyon and Anderson Canyon, lands that are now a part of Julia Pfeiffer Burns State Park (named for his wife's favorite aunt). The Ewoldsen Trail at the park is named for him, to honor his labor in restoring many historic features of the ranch after the state acquired it in 1961. (Courtesy Ewoldsen family.)

The northern Ventana Peaks are captured in this *c.* 1930 Harold Luck photograph, taken near Cold Spring on the Coast Ridge. "The Window" can be seen as a small notch on the crest between No Name Peak (left), also called Kandlbinder Peak, elevation 4,653 feet, and the partially obscured Ventana Double Cone (right). The peaks, in the heart of the Ventana Wilderness of Los Padres National Forest, form a divide separating the four rivers of the northern Santa Lucias: the Carmel, Big Sur, Little Sur, and the Arroyo Seco branch of the Salinas. The Ventana is the source of many other place names, such as Ventana Creek, Ventana Double Cone, and the Ventana Resort in Big Sur. (Courtesy Katherine P. Short.)

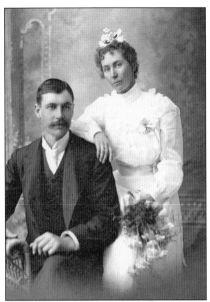

Samuel Marshall Trotter is shown with his first wife, Abigail Gregg, on their wedding day, March 26, 1901. Abigail, who died the next year, was the sister of Charles Gregg, who married Alta Bixby, daughter of North Coast pioneer Charles Bixby. Sam, born in Missouri on December 2, 1871, came west and worked in the redwood timber in Santa Cruz County. In 1893 he made his first visit to Big Sur, staking a timber claim on the North Fork of the Little Sur. He was a bigger-than-life personality, noted for his prodigious strength and abilities as a lumberman. He died in Big Sur on December 8, 1938. (Courtesy Sylvia Trotter Anderson.)

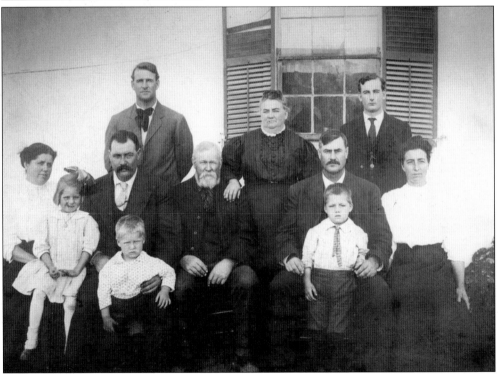

The extended Trotter family, c. 1912, from left to right, included Flora (married to Charles Trotter), her daughter Dorothy, Sam (holding son Henry), Sam's brother Charles (born 1880), Sam's father Martin Alexander Trotter (1841–1916), Phoebe (Mrs. Martin) Trotter, Sam's brother John E. (1864–1929) with Sam's son Roy, Paul (another of Sam's brothers, born 1891), and Adelaide Pfeiffer Trotter (1879–1922), Sam's second wife (married June 7, 1905). Sam and John were sons of Martin and his second wife, Sarah Jane Shinn. Charles and Paul were the sons of Martin and Phoebe, his third wife. (Courtesy Sylvia Trotter Anderson.)

Sam Trotter lived and worked for many years in Mule Canyon, where he is pictured in the late 1930s. Here, Trotter built the Trails Club for a consortium from Principia College, a Christian Science school in Elsah, Illinois. The log cabin is now part of the Nepenthe complex of buildings. Trotter also built several vacation homes for this group of academics and artists in the nearby subdivision of Coastlands. Trotter was also involved in a number of other enterprises, including the harvesting of redwood timber and tan bark (used for curing leather), road and bridge building, and the shipping of forest products and slaked lime from such doghole ports as Notleys, Bixby, Partington, and Saddle Rock landings. (Courtesy Sylvia Trotter Anderson.)

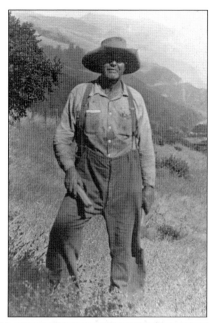

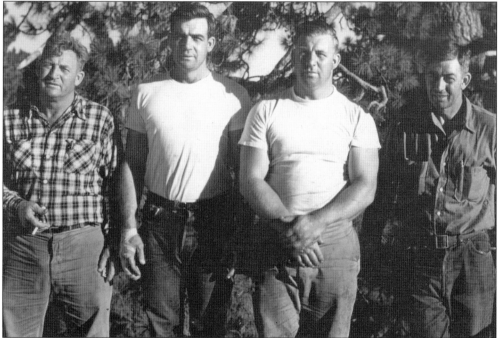

The four sons of Sam Trotter shown here c. 1950 are, from left to right, Henry (1908–1987), Walter (1920–1990), Frank (1918–1989), and Roy (1906–1984). Their sister Lillian, born in 1913, died in 1997. Henry worked for years as an oil company engineer in Saudi Arabia. Roy was an engineer and hydrologist, and offered his land use planning expertise to the Big Sur community. Frank and Walter married sisters Fern and Guelda Fenton (respectively), who were members of a pioneer Salinas family. Frank and Walter, active in local ranching, were also skilled carpenters, builders, and woodsmen; they donated countless hours to the local volunteer fire brigade, grange, historical society, health center, and library. (Courtesy Sylvia Trotter Anderson.)

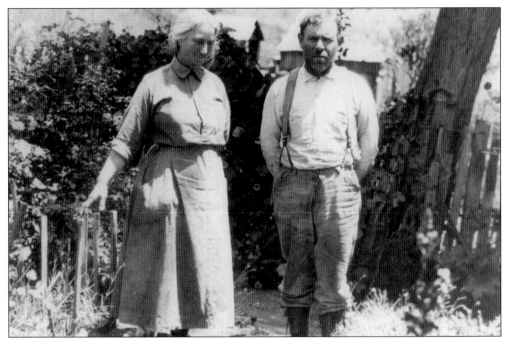

Julia Pfeiffer Burns (1868–1928) stands with her husband, John (1876–1943), at their home at Slates Hot Springs in this photo from 1921. John, who wed Julia in 1915, had also spent most of his life in Big Sur, ranching and working as a farm laborer. John's father, Edward Burns Sr., claimed 160 acres near Barlow Flats in the Big Sur backcountry. In 1905, long after his father's death, John obtained government title to the land. The Burnses ran cattle on the South Coast, including Saddle Rock Ranch. When Helen Hooper Brown donated this property to the state, she stipulated that it be named in honor of Julia Pfeiffer Burns, "a true pioneer." (Big Sur Historical Society.)

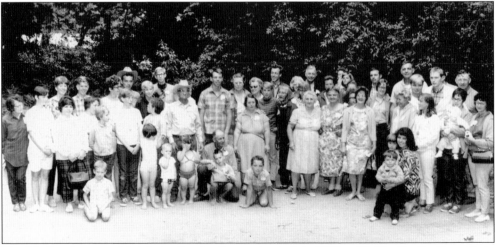

The Pfeiffer clan assembled for its first family reunion in July 1968 at Pfeiffer Big Sur State Park. At this event, 84 descendants of Barbara and Michael traveled from as far as Challis, Idaho, and Ketchikan, Alaska. Other reunions were held later, with nearly 150 people attending the 1971 get-together. Shown in this photo are Danis, Grimeses, Cains, Von Protzes, and Kelches, not to mention numerous Trotters and Pfeiffers. (Courtesy Sylvia Trotter Anderson.)

Elfrieda Swetnam Hayes (1891–1988) was the youngest child of Ellen and Isaac Newton Swetnam. At the time of her birth, the family lived on their farm in Garrapata Canyon. The Swetnams soon purchased a ranch at Palo Colorado Canyon near Notley's Landing, a busy shipping port for tan oak, redwood lumber, and split redwood products such as shakes, fence posts, and oyster poles. As Elfrieda recalled in her memoirs, "When the Notleys were actively running the landing, [with] schooners loading and unloading, it became a sort of social center, as well as a business center for the whole community." Elfrieda's sister Florence was married to John Pfeiffer. (Courtesy Ewoldsen family.)

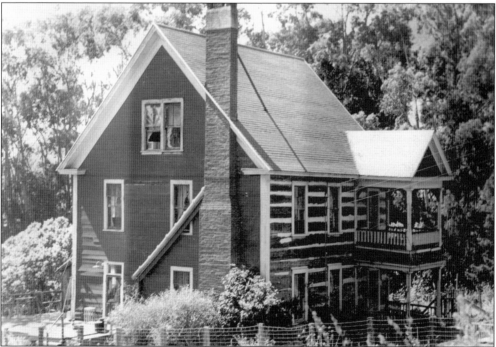

The Swetnam house at Palo Colorado Canyon, built in 1898, remains as a landmark of the early pioneer days. The Swetnams had previously staked a claim in the early 1880s on the North Fork of the Little Sur, the present location of Pico Blanco Scout Camp. The Palo Colorado property was previously owned by Antonio María Vasquez (brother of the bandit Tiburcio), Esequiél Soberanes, and Capt. Volney Cushing. After the Swetnams left, the Trotter family resided here for many years, during which time all their children were born. Later purchased by Electa Grimes, the place is still owned by the Grimes family. (Big Sur Historical Society.)

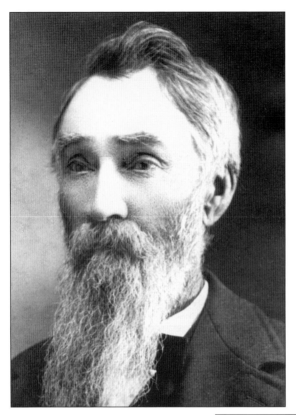

Thomas J. Evans (1836–1919) was born in Cardiganshire, Wales, the eldest of 14 children. The family emigrated to the United States when Thomas was a child. He later came west, finding work driving 16-horse teams in the Placerville area. In 1869 Evans invested in a portion of Rancho Piedra Blanca, a Mexican land grant at the south end of the Big Sur Coast in northern San Luis Obispo County. Evans also staked a homestead claim in southernmost Monterey County, just south of Salmon Creek; the 160 acres were patented to him in 1890. Evans maintained a rivalry with both George Hearst and his son, newspaper baron William Randolph Hearst. Although the Hearsts wanted Evans's land, the stubborn settler refused to sell. (Courtesy Jean Evans Murray.)

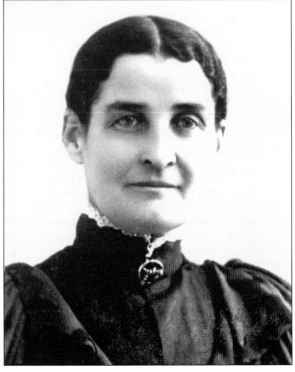

Thomas Evans married Mary Jarmon in 1869. Of Welsh descent, she had lived in Wisconsin in the large Welsh community at Waukesha, where Thomas had also lived as a youth. One of Mary's sisters wed Thomas's brother John. Another sister, Elizabeth, came west and married Capt. Lorin Thorndyke, first keeper of Piedras Blancas Lightstation near Thomas's home place. After Elizabeth died, Thorndyke wed her sister Margaret. Yet another Jarmon sister, Martha, was the wife of South Coast pioneer Benjamin Franklin Muma. Mary and Thomas Evans had eight children: John C., William J., Katherine, Anabel, George W., Walter Raymond, David E., and Thomas C. Evans. (Courtesy Jean Evans Murray.)

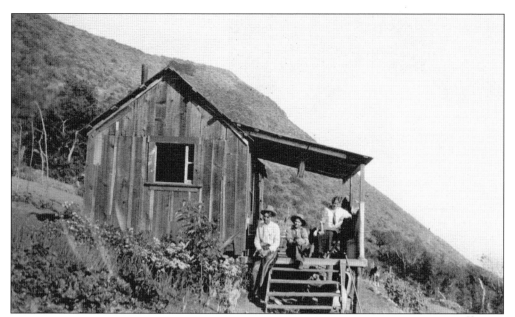

Thomas C. Evans, born in 1876, owned a 158-acre parcel known as Kozy Kove, on the coast just south of Salmon Creek. This property was immediately northwest of his father's homestead. Evans had also homesteaded a 160-acre claim in 1903 adjoining that of his brother John at San Carpóforo Creek, known locally as San Carpojo. At Kozy Kove, Tom and his wife, Evelyn (born in 1884), raised their two daughters, Patricia and Jean. The Evanses had met while she was teaching at the Polar Star one-room schoolhouse, located a short distance north of San Carpóforo Creek. Shown in this picture, from left to right, are Tom, brother George, and Evelyn at their Kozy Kove cabin shortly after Tom and Evelyn married in 1916. (Courtesy Jean Evans Murray.)

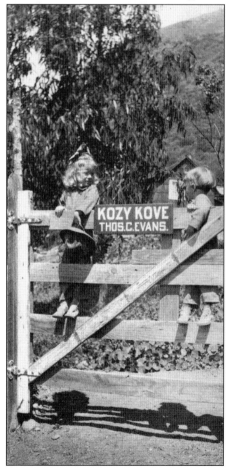

Patricia (left) and Jean, the two children of Tom and Evelyn Evans, pose at the Kozy Kove gate in this c. 1921 photo. This gate was placed across the old Coast Trail, which passed through the Evans property. Prior to the construction of Highway 1, this trail served as the principal means of travel from San Simeon northward into the heart of the Big Sur country. In the mid-1950s Evelyn Evans sold the 40 acres containing the house, barn, and outbuildings to Willis and Dorothy Pitkin from El Monte in Southern California. The remainder of their ranch, now part of Los Padres National Forest, was purchased by the U.S. Forest Service. (Courtesy Jean Evans Murray.)

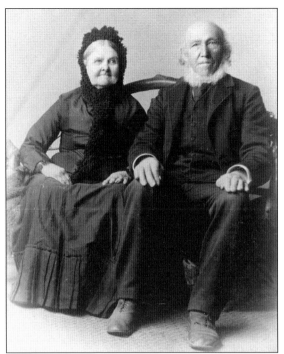

Mary Ann and William Waters Sr., photographed on February 19, 1893, settled in what is now Carmel Highlands in 1868. They journeyed from New Bedford, Massachusetts by ship, making the crossing of the Isthmus of Panama by train. With them were five of their six children: Martha, Joseph, John, William Jr., and Edmund. The Waterses built their home at the site of today's Highlands Inn, just south of Point Lobos State Reserve. William Waters Sr., born in 1798, died in 1896 within weeks of his wife, Mary Ann, born in 1811 in Ireland. (Courtesy Margaret Waters Harrell.)

José Antonio Esequiél Soberanes Sr. and his wife, María Ygnacia Moreno de Soberanes, were neighbors of the Waterses. In 1769 Esequiél's grandfather, José María, accompanied Gaspar de Portolá during the expedition that founded Alta California. Esequiél's mother, Isidora Vallejo, was a sister of J.B.R. Cooper's wife, Encarnación. In 1860 the Soberaneses purchased a town house in Monterey, Casa Soberanes, now part of Monterey State Historic Park. Esequiél (1822–1896) owned the Palo Colorado Ranch in 1866, next year buying the ranch at Soberanes Canyon from David Castro. Soberanes stocked his range with cattle from Rancho Los Ojitos, owned by his father, Mariano de Jesús. While driving this herd, Esequiél was beset by a grizzly bear, which he dispatched with a pistol. (Courtesy Margaret Waters Harrell.)

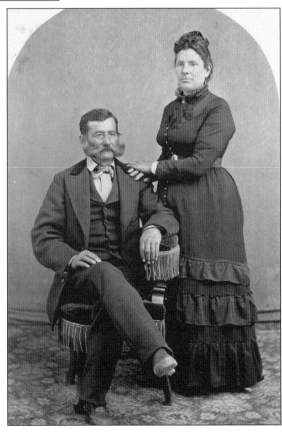

Esequiél and María's daughter, Rosa Laura Soberanes Waters, stands with her son, Edward (left), and her husband, Edmund. One of twelve children, Rosa spent much of her youth at the Malpaso Ranch, as the family called their place south of Malpaso Creek. The Soberaneses enjoyed making music and were often joined by their neighbor, Edmund Waters, who played the accordion. Rosa and Edmund married in 1890 and ranched near King City in the Salinas Valley. Their son Edward wed Juanita Agnes Soberanes, a distant cousin descended from Feliciano, brother of Mariano de Jesús. Edward made many pack trips to the South Coast of Big Sur c. 1900, when he visited his aunt, Bersabé Soberanes, wife of Thomas Slate of Slate's Hot Springs. (Courtesy Margaret Waters Harrell.)

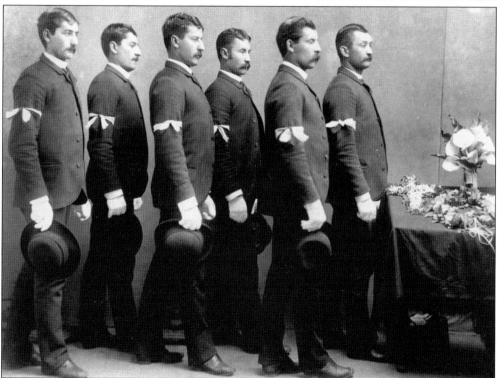

Descendants of the proud Catalonian people of Spain, the Soberanes brothers, shown here at the funeral of their mother, María Ygnacia (1833–1888), are, from left to right, Santiago, Bernardo, Gaspar, Ygnacio, Esequiél Jr., and Dimas. Santiago was the guide for artist Maynard Dixon when the latter made a visit to the South Coast of Big Sur in 1897. Dixon later wrote about this trip, referring to Santiago as "a fine *caballero,* as the girls called him." Dixon also met Santiago's brother Dimas and his wife, Isabelle, whose homestead was located on the mountain above Slate's Hot Springs. (Courtesy Margaret Waters Harrell.)

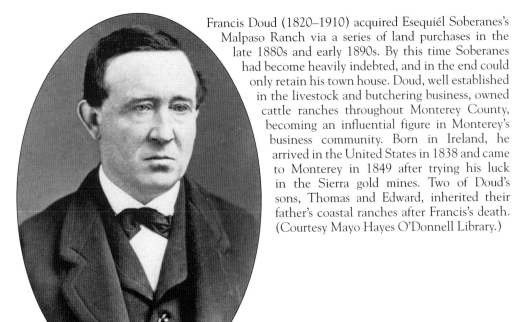

Francis Doud (1820–1910) acquired Esequiél Soberanes's Malpaso Ranch via a series of land purchases in the late 1880s and early 1890s. By this time Soberanes had become heavily indebted, and in the end could only retain his town house. Doud, well established in the livestock and butchering business, owned cattle ranches throughout Monterey County, becoming an influential figure in Monterey's business community. Born in Ireland, he arrived in the United States in 1838 and came to Monterey in 1849 after trying his luck in the Sierra gold mines. Two of Doud's sons, Thomas and Edward, inherited their father's coastal ranches after Francis's death. (Courtesy Mayo Hayes O'Donnell Library.)

John Waters (left) and Bert Stevens are pictured at Stevens's ranch on Partington Ridge, c. 1890. John, the elder brother of Edmund Waters, married Rachel McWay, whose family settled south of Partington Creek in the canyon that now bears their name. Stevens had been a partner of John Partington; together they engaged in redwood and tan bark harvesting, and developed a ship landing just south of the Partington creek-mouth. This historic site, known as Partington Landing, is now part of Julia Pfeiffer Burns State Park. Stevens lived on Partington Ridge long after the Partingtons moved away. He was described by Maynard Dixon as "a philosopher somewhat, and a good talker, too, for he was evidently well-read." (Courtesy Margaret Waters Harrell.)

The Partington homestead, called "Seaview Ranch," seen here March 1917, overlooked Partington Canyon, and is where John and Laura Partington and their five children settled in 1874 after a grueling journey from the north. One of their mules fell off the narrow Coast Trail and dragged three other mules with it, along with friend and future neighbor Thomas Slate, who was seriously injured. The family lost many of their possessions, and the rest of their belongings were destroyed when the steamer *Ventura* sank near Point Sur the next year. Nevertheless, the family persevered, establishing a thriving homestead that was "the garden spot of the section," as their daughter, Millicent Partington Dolley, later recalled. (Photo by Lewis Josselyn; courtesy Pat Hathaway; 71-01-BS-219).

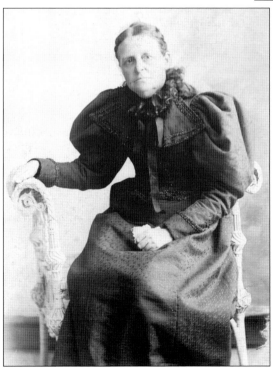

Laura Harmon Partington (1841–1933) was born in Machias, Maine. After the death of her first husband, Franklin Longfellow, she traveled to San Francisco, where a brother lived. Here Laura met John Partington, an oil company engineer who was prospecting in the Santa Cruz Mountains; they married in 1865. Laura Partington was remembered by her granddaughter, Mrs. James Millington of Monterey, as "a fiery little woman, about as big as a minute, who was busy all the time." John Partington died in 1888, and the family moved to Monterey a few years later. This portrait of Laura Partington was taken in the early 1900s. (Courtesy Sharon Ziel.)

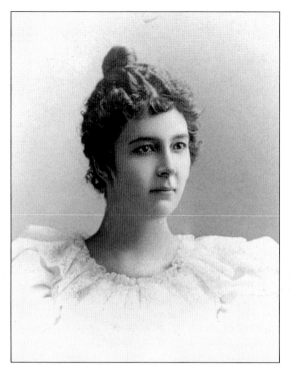

This 1890s picture of Ollie Partington was presented to her friend and neighbor, Bert Stevens. Ollie later married James Myers of Priest Valley in southeastern Monterey County. James's father, Andrew J. Myers, was the first postmaster there. Ollie and James had two sons, Baxter and Andrew. The Myers Ranch, homesteaded in 1891, was the site of a famous oak tree from which Father Dorotéo Ambris of Mission San Antonio hung a bell and offered religious services to the resident Native Americans. Here, according to local legend, the famed explorer and scout Kit Carson encountered the worthy priest in 1864 and gave the name to the fertile valley. (Courtesy Margaret Waters Harrell.)

The Partington children, shown here later in life, from left to right are: (front row) May Partington Devereaux and Millicent Partington Dolley; (back row) John Frank Partington, Ollie Partington Myers, and Fred Partington. In 1909 May was claimant to 160 acres extending from Partington Ridge northerly into adjoining Torre Canyon. She never received title to the land; except for the northernmost 40 acres, the parcel was later acquired by Jaime de Angulo. Fred patented a claim of his own to the west of May's in addition to holdings in upper Partington Creek. In the early 1920s the Partington properties were sold to the group from Principia College, which also purchased part of the Post Ranch. (Courtesy Sharon Ziel.)

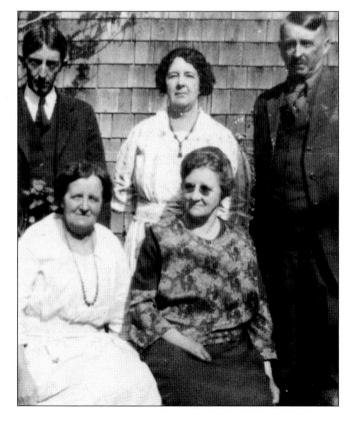

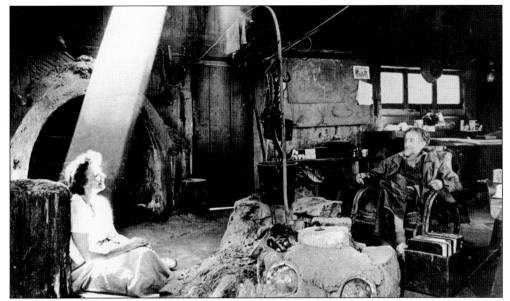

Jaime de Angulo (1887–1950), shown here with novelist Lynda Sargent at Rancho de los Pesares, was photographed by George Cain in the late 1940s. Angulo, born in Paris to Spanish expatriates, was an authority on the native languages of California and Mexico. He had a medical degree as well, balancing his academic inclinations with a love of horses and the outdoors. While staying in Carmel, c. 1915, Jaime made his first trip to Big Sur, escorted by Rojelio Castro, who had filed on the bulk of the May Partington claim. Castro transferred his interest to Angulo, who received a homestead patent in 1920. Angulo spent the rest of his life at los Pesares, interspersing his time with linguistic fieldwork and teaching stints at the University of California, Berkeley. (Courtesy Marjorie Van Peski.)

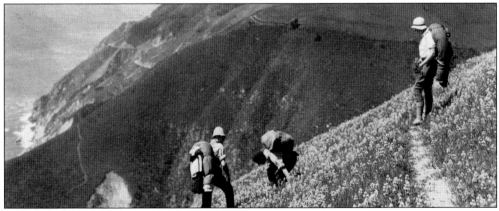

A group of hikers admires a field of lupine on the Angulo Ranch in this 1930s Harold Luck photo. Jaime enjoyed visits by his friends, often inviting elite members of academia to los Pesares. For a while he operated the place as a kind of dude ranch, and in a brochure cautioned prospective guests that "If you are looking for comfort, don't come here! You will have to sleep in a tent, or under the stars. This place is still in the wilderness, far from civilization. The food is nothing extra. The cook is crazy. Sometimes he cooks in Chinese, sometimes in French, and again in Spanish, and sometimes in his own . . . As to the weather. In April and even May, it is still pretty raw, but the hills are at their greenest, and the wild flowers in bloom." (Courtesy Katherine P. Short.)

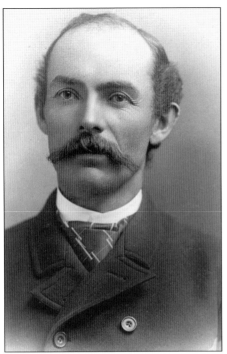

William D. Cruikshank was the son of William T. Cruikshank, who homesteaded at Villa Creek on the South Coast of Big Sur. The family had at least two homestead claims in the area, patented in 1883 and 1887. They settled in what was known as Los Burros Mining District, established in 1875. It wasn't until 1887 that the big gold strike was made by W.D. Cruikshank at his Last Chance claim. A Los Padres National Forest hiking path known as the Cruikshank Trail passes through the former Cruikshank ranch lands; Upper Cruikshank Camp, at the site of their home, is one of the finest campsites in the Big Sur backcountry. (Courtesy James R. Krenkel.)

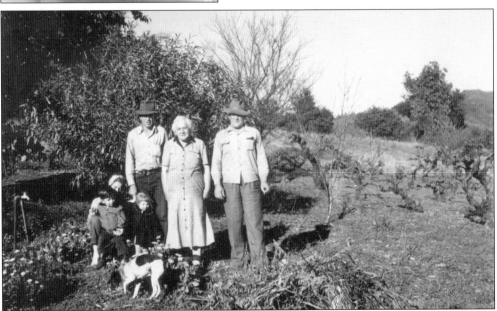

Members of the Krenkel family gather around family matriarch Margaret Krenkel in this early 1950s photo taken at at the Krenkel Ranch. Shown, from left to right, are James R. Krenkel, his mother Robbie, sister Charlene, father Charlie, grandmother Margaret, and uncle Bill. Margaret (1873–1963) lived at the ranch above Alder Creek until 1959, long after the death of her husband, James Monroe Krenkel, in 1943. He was a second-generation gold prospector, born in the Sonora, California, gold country in 1862, and came to Los Burros in 1882. J.M. Krenkel met Margaret at a dance in Jolon, east of Los Burros, and they were married on May 23, 1902. (Courtesy James R. Krenkel.)

Charlotte (Lottie) Woodworth, photographed here *c.* 1896, was born in 1878 in San Juan Bautista, California, to William Alonzo Woodworth and Rosilla Hysell Woodworth. Both the Woodworths and the Hysells were settlers in the San Carpóforo watershed, the Woodworths having come to the coast in 1879. In 1905 Lottie homesteaded her own claim at the headwaters of San Carpóforo Creek, a place still known as Lottie Potrero (from the Spanish *potrero,* a small, flat pasture). Today it is the site of a U.S. Forest Service camp by that name. In 1907 Lottie married Louis Pugh of Soledad, related by marriage to Henry Melville, legendary miner of Los Burros. (Courtesy Patrick Gileau.)

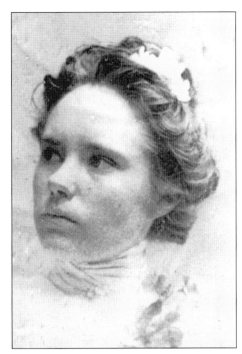

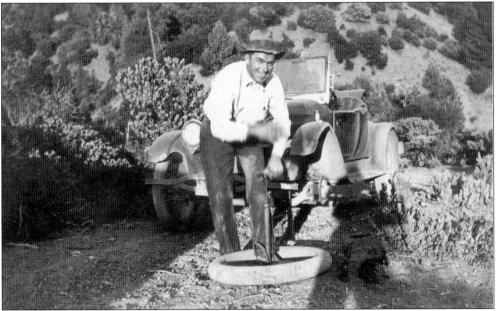

Charlie Krenkel is shown here changing a tire on the road leading to the Krenkel Ranch at Alder Creek in Los Burros Mining District in the 1930s. Krenkel was born at the ranch in 1906 and spent his life on the South Coast, passing away in 1989. Charlie, a blaster, worked from 1947 to 1970 for the California Division of Highways, today's Caltrans, which oversees the maintenance of Highway 1. His son, James, began working for Caltrans the year his father retired, and is stationed at Willow Springs Maintenance Station on the South Coast of Big Sur. Charlie was known as a fine raconteur who would readily relate the tales of Los Burros and the legends of its mines. (Courtesy James R. Krenkel.)

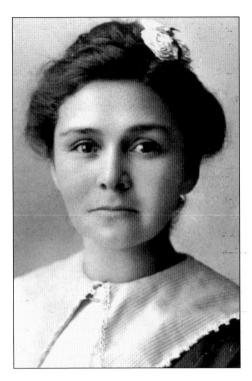

Josephine Rey Boronda, known as Josie, is shown here in 1913. Born in 1880 in Castroville, Josie was the daughter of José de los Santos Boronda, who was reportedly living on the coast south of Vicente Creek as early as 1872. Josie's great-grandfather, Manuel Boronda, was 19 years old in 1769 when he accompanied Portolá and Serra on the expedition from Mexico that founded the province of Alta California. On September 19, 1895, Josie married Riel Dani, born in 1871, the son of Gabriel and Elizabeth Dani. Riel and Josie lived on the coast just south of Big Creek until 1904, when they moved to the San Antonio Valley east of Big Sur's South Coast. Their nine children were Fredrika, Ellen, Mary, Julia, Job, Emma, James, Lavina, and Adelaide. Riel died in 1930 and Josie in 1971. (Courtesy Stan Harlan.)

Two Boronda cousins and their relatives are seen in this picture from the 1890s. Shown seated are Lupe Banjales Boronda (left) and her sister, Maco Banjales Gilroy Maladrago. Standing, from left to right, are Lino Boronda (Lupe's husband), Mercedes Gilroy (sister of Maco and Lupe), and Bautista Boronda (Lino's cousin). Lino was the brother of Josie, and together with his wife, Lupe, ran a dance hall in San Francisco. Maco was formerly married to Alvino Gilroy, a descendant of John Gilroy, the Scot who left his ship in Monterey in 1814, ill with scurvy. He settled in the Santa Clara Valley, on the Rancho San Isidro land grant of his wife, María Clara Ortega, now the location of the city of Gilroy. (Amelie Elkinton Collection; courtesy Mayo Hayes O'Donnell Library.)

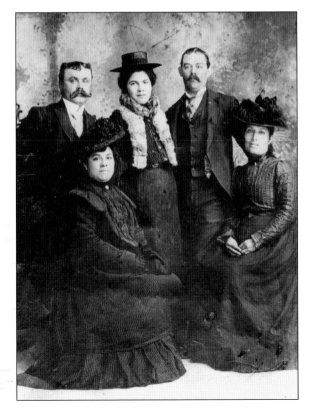

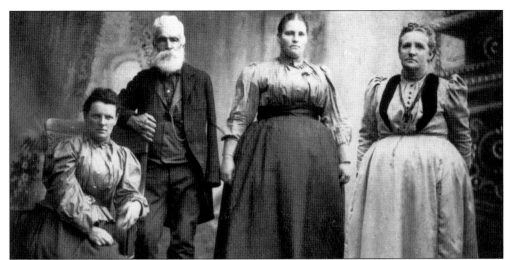

This portrait of the Dani family, c. 1900, shows, from left to right, Mary Elizabeth, her father Gabriel (who lost his arm in a threshing machine accident), her sister Lucia, and her mother Elizabeth. Gabriel (1832–1908), married the Yorkshire, England native Elizabeth Brown (1845–1931) in 1863. They came to the South Coast in 1876 and stayed at the place later settled by José de los Santos Boronda. The next year they moved to their own homestead a mile or so to the east, along the stream now called Dani Creek. The location is today part of Immaculate Heart Hermitage above Lucia. The Danis had 11 children, many of whom married into local families: Alice wed William Pfeiffer; her brother, Alvin, was married to both Mary Ellen and Kate Pfeiffer; Ada married Wilber Harlan; and Mary (pictured here) married Nes Swending, with whom she homesteaded at the headwaters of Anderson Creek. (Courtesy Constance McCoy.)

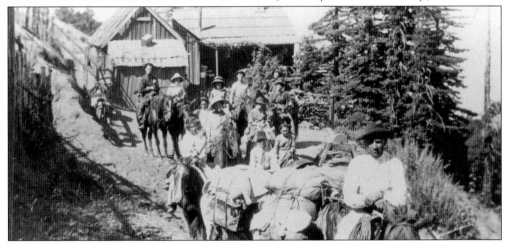

The Gamboa family, neighbors of the Danis and the Borondas, lived just south of Big Creek. Pictured here around the turn of the last century is a group of riders preparing to depart the homestead of Sabino Gamboa, located on what is now Landels-Hill Big Creek Reserve, a holding of the University of California. Gamboa married Anita Avila in 1878 in a ceremony performed by Father Ambris and reportedly was living on the coast by the early 1880s. Gamboa's homestead was patented in 1891; his death occurred in 1903. In 1911 author J. Smeaton Chase visited the Gamboa place and wrote, "The situation of Gamboa's Ranch is superb, the very finest I know. The house, an old and picturesque one, hangs like an eyrie on the mountainside . . . " (Big Sur Historical Society.)

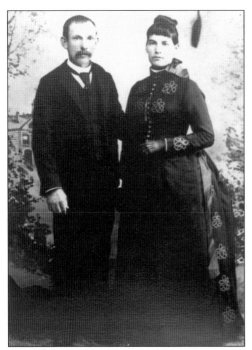

Ada Amanda Harlan (1867–1942) and her husband, Wilber Judson Harlan, are pictured on their wedding day, July 7, 1889. Ada, born in Beaver County, Utah, was the third child of Gabriel and Elizabeth Dani. When she was still a toddler, Ada's family came west, settling for a period in Wilmington, near Los Angeles, where her father drove a stagecoach between the two towns. The family then moved to San Francisco, then north to Petaluma, and had arrived in San Juan Bautista by 1871. Ada, who attended the Redwood School built by her father in 1879, was interred in the Harlan family cemetery on the home ranch. (Courtesy Stan Harlan.)

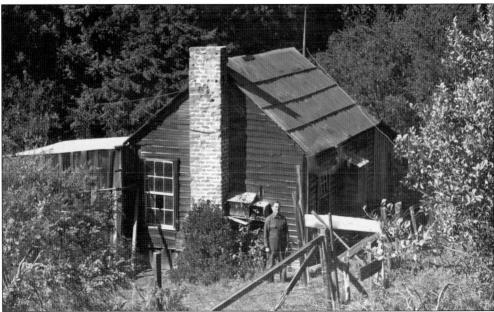

This is the first home of Wilber and Ada Harlan, built by Wilber in 1885 of hand-split redwood. When he needed more supplies, Wilber would walk over the mountains to the Salinas Valley; after returning from one such trip, he found that an employee of a nearby homesteader, Agapito Manuel Lopez, was in the process of building another cabin just 15 feet away from Wilber's. Lopez had intended to intimidate Harlan by asserting his own claim on the unsurveyed land, but Harlan prevailed. Claude Harlan, the son of Wilber's half-brother, George Marion Harlan, is seen in this 1949 image. (Amelie Elkinton Collection; courtesy Mayo Hayes O'Donnell Library.)

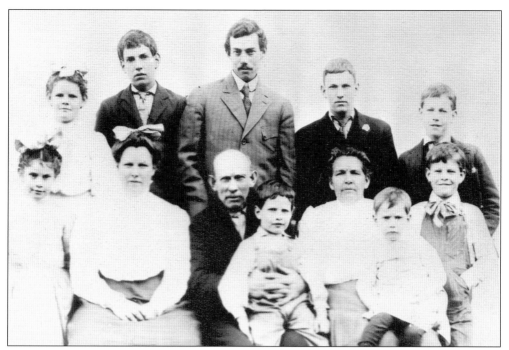

The Harlan family, photographed c. 1911, from left to right, are (front row) Ada Alice (1904–1981), Lulu May (1892–1984), Wilber Judson, Frederick Levi (1905–1974), Ada Amanda, Marion David (1908–1983), and Albert Victor (1901–1917); (back row) Hester Elizabeth (1899–1992), James Arthur (1895–1966), Aaron Wilber (1890–1964), George Alwin (1893–1985), and Paul Drummond (1897–1967). Hester and James married into the Victorine family of the North Coast of Big Sur; Hester wed Avelino Victorine, and James married Angelus Victorine. (Courtesy Stan Harlan.)

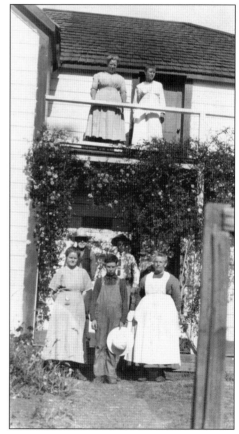

This picture was taken in 1921 at the second Harlan home, built in 1901. The photograph was taken during a visit to the Harlans by Monterey County librarian Anne Hadden, who was delivering books to the remote ranch, and shows, from left to right (front row) Hester Harlan, Marion Harlan, and Ada Amanda Harlan; (middle row) Wilber Harlan and his son, Fred; (on balcony) Lulu Harlan and Alice Stewart Harlan. Alice was a teacher at the Redwood School and married Paul Harlan in 1920. After her death in January 1940, Paul wed Doris Picar on December 19, 1940. (Courtesy Stan Harlan.)

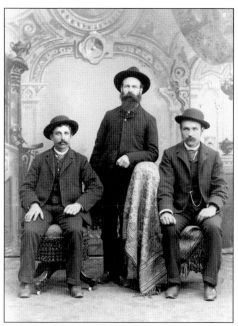

These three brothers-in-law, photographed in the 1880s, from left to right, are John McWay, John Waters, and Christopher McWay Jr. Waters married Rachel McWay, whose brother, John (Jack) McWay, a sailor, was born in New York in January 1860 and later married local schoolteacher Nimpha Narvaez. Christopher McWay Jr., known as "the carpenter of the coast," was born about 1854, also in New York. He helped build the second Redwood School at Lucia in 1906 and also built structures for John Little at Slate's Hot Springs, and for the Post family in 1895. (Courtesy Margaret Waters Harrell.)

This view of McWay Canyon was taken by Lou G. Hare c. 1900. At the far right is the barn built by the McWays, probably in the 1880s. Remnants of this structure still stand in Julia Pfeiffer Burns State Park. Official records indicate the McWays, including father Christopher McWay Sr. and his wife, Rachel, were established at McWay Canyon by 1880. According to their daughter, Antoinette McWay Little, they arrived on the coast about 1877. Another daughter, Catherine, born in New York in 1869, was by 1900 married to Charles Beale, a tan bark peeler. (Courtesy John and Helenka family collection.)

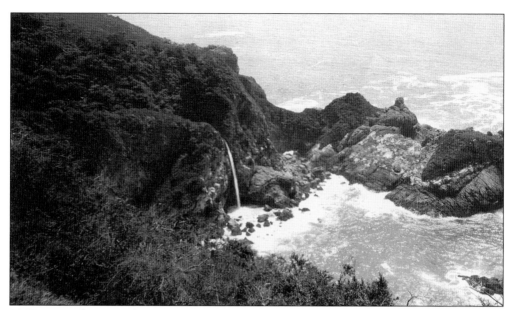

McWay Creek enters the Pacific Ocean by way of the scenic 80-foot McWay Falls, shown here in this c. 1915 photo by John A. Little. To the right of the falls is the formation known as Saddle Rock, resembling a high-cantled Spanish riding saddle and the source of the place name Saddle Rock Ranch. Just south of Saddle Rock, at the mouth of Anderson Creek, is the site of Saddle Rock Landing, established by Sam Trotter as early as 1908. The property had originally been acquired by Christopher McWay Sr. as a cash sale from the U.S. government. (Courtesy Jeannine Little Karnes.)

This unidentified equestrienne is enjoying a ride by the Waters house in McWay Canyon. This cabin was built to replace the original home on the site constructed by the McWays. John and Joseph Waters, beekeepers who maintained some 125 hives, lived in the first cabin before it burned to the ground. This occurred while beeswax was being refined, a process that required heating the wax in a large tub of water placed on a wood-burning stove. Unattended, the wax boiled over and set the house on fire. The cabin seen in the photo was later enlarged, and in 1929 it, too, burned. This time a cook trying to get a fire going in the stove mistakenly poured gasoline on it instead of kerosene. (Courtesy Margaret Waters Harrell.)

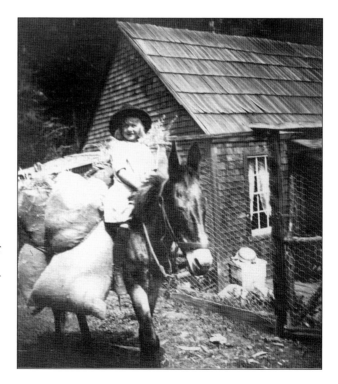

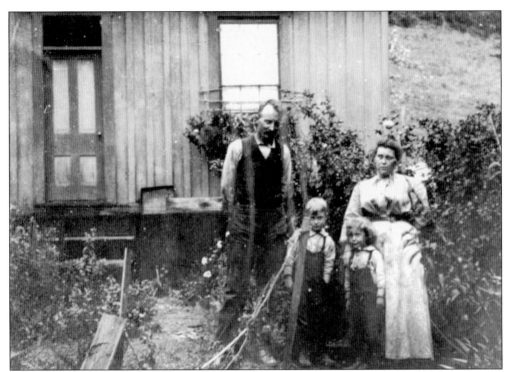

John Anderson Little (left) is shown c. 1905 with his sons Deal A. Little (left) and John D. Little, and wife Antoinette McWay Little. They are shown at their home, originally built by Thomas B. Slate at Slate's Hot Springs. In 1894 Slate sold the property to John Little's brother, Milton Little Jr. Their father, Milton Sr., had come to Monterey in 1844 and went into the mercantile business with J.B.R. Cooper's half-brother, Thomas Oliver Larkin. Milton later took title to the community now called New Monterey, and passed away in 1879. Milton Jr. sold the hot springs property to John, who had a homestead claim in upper Hot Springs Canyon. (Frank Trotter Collection, Big Sur Historical Society.)

The Little kids, shown with Beauty the mule, from left to right, are unidentified, Deal A. Little, unidentified, and John D. Little. This picture was taken in 1909, the year Mrs. Little moved with her children to Pacific Grove so they could attend school. The old Slate house, shown in the background, was located at the site of the present-day laundry at Esalen Institute. Deal Little inherited much of his father's South Coast lands, and enjoyed entertaining deer-hunting friends on his backcountry properties. Deal worked for many years as a taxi dispatcher in Monterey, where his grandfather had been a "Second *Alcalde*" (vice-mayor) during the Mexican days. (Courtesy Jeannine Little Karnes.)

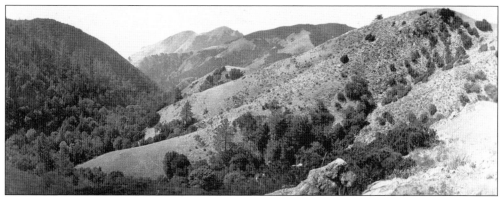

This scenic photograph shows the headwaters of Hot Springs Canyon, looking out to the ocean. John Little patented a homestead claim here, receiving title to the 160 acres in 1904. This picture was taken by Little, accompanied by his friend Elizabeth King Livermore, a Marin County socialite with a passion for the South Coast. She acquired properties in the area by researching title to unclaimed but sightly lands, then filing on them herself. She thus became owner of a parcel adjoining Slate's Hot Springs, where Sam Trotter built her a vacation retreat. In 1952 Livermore donated the land to the state for a park; John Little State Reserve stands today as a memorial to these colorful individualists. (Courtesy Jeannine Little Karnes.)

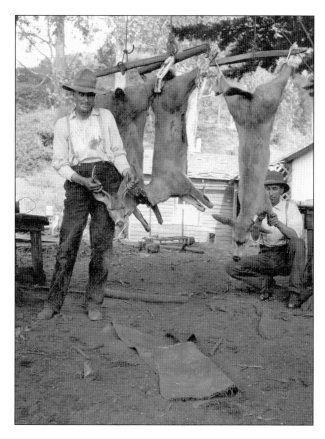

John A. Little (left) is shown at his Slate's Hot Springs home with the products of a successful hunt. Cattle ranchers such as Little recognized that beef was a valuable commodity. When meat was served, as likely as not it would be venison rather than the rancher's own "stock in trade." In the early 1900s Little sold the hot springs to Salinas physician Henry C. Murphy, who achieved a certain fame as the doctor who delivered the infant John Steinbeck. John A. Little is believed to have died in 1928 or 1929. (Courtesy Jeannine Little Karnes.)

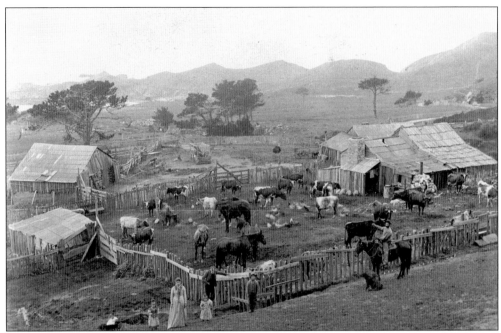

This 1893 view shows the Victorine Ranch, on the north side of Malpaso Creek, with Yankee Point in the distance. In the foreground, from left to right, are Joseph Victorine Jr. (in basket), Mary Victorine, Louisa Correia Victorine, Lillian Victorine, William Towle (the former owner of the property), unidentified, and Joseph Victorine Sr. The senior Joseph was born in the Azores in 1864. His father, Antonio Victorino, had come from Faial, the Azores, to the United States with a group of 18 whalers about 1860. By 1861, 17 of these men had founded the whaling company at Point Lobos. In 1870, after he began his dairy operation near San José Beach, Antonio brought his wife, Mary, and their eight children, from the Azores to the Monterey coast. (Courtesy Walter Victorine.)

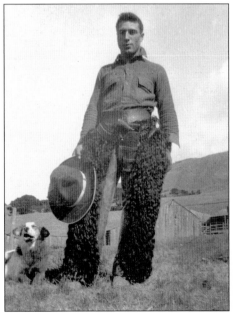

Avelino Victorine, one of the sons of Joseph Victorine Sr., sports a fine pair of angora chaps in this 1920s picture at the newer Victorine Ranch, on the south side of Malpaso Creek, where the family moved their base of operations c. 1895. Avelino married Hester Harlan in 1931. When J. Smeaton Chase rode through in 1911, he had this to say about the Victorine kids: ". . . five jolly children took possession of me . . . In five minutes Avelino was on my back, Ernesto and Braulio were punching me jovially, Angeles of the soft brown eyes was filling my hands with her best-beloved flowers, and fat José was planning a rescue in order to show me a phenomenal farrow of pigs." (Courtesy Walter Victorine.)

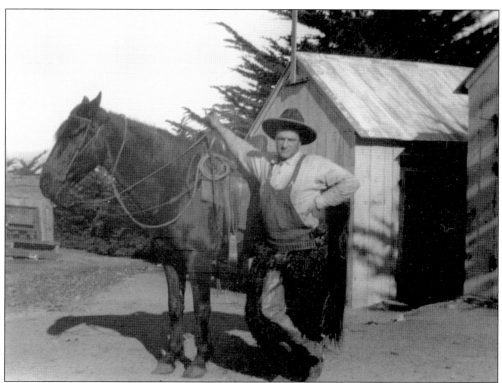

Joseph Victorine Jr. stands with his horse, Danny, at the ranch south of Malpaso in this photo from the early 1920s. Joseph Jr. and his brothers worked hard on the 1880-acre ranch until Ernest and Avelino moved away, leaving only Joseph and Braulio to manage the operation. In 1925 Braulio died, tragically, when his horse-drawn hay rake rolled over him. Joseph then sold the ranch to the Carmel Development Company, the concern headed by Frank Powers and James Franklin Devendorf that had earlier founded the town of Carmel-by-the-Sea. (Courtesy Walter Victorine.)

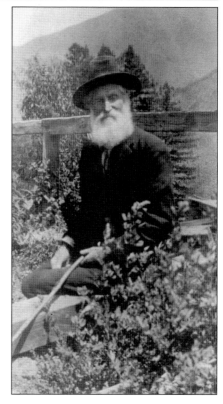

Edmund Cogswell Sterritt is shown at his place on Garrapata Ridge above Palo Colorado Canyon in this photo from the early 1900s. Sterritt was born in Nova Scotia, Canada, in June 1844 and became a naturalized citizen in 1887. His 160-acre homestead was patented in 1892. By 1900 Sterritt was divorced from his wife, Rachel, who is listed as a farmer in the U.S. census for that year. She and her three children are enumerated in a different household from Edmund, who, it is said, "had many wives." Sterritt's farm is now part of Glen Deven Ranch, an 860-acre property owned by the Big Sur Land Trust. (Courtesy Mayo Hayes O'Donnell Library.)

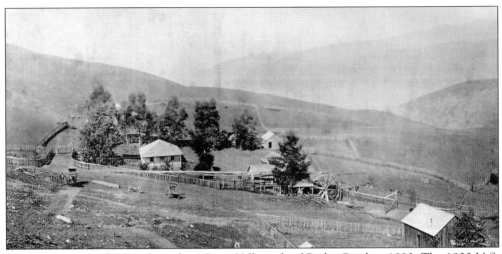

This photo shows the Brazil ranch at Serra Hill south of Bixby Creek *c.* 1890. The 1900 U.S. census lists the family of Antonio Brazil, his wife, Mary, and their six children. Antonio was born in May 1850 in the Azores; Mary was born in California in August 1864 to parents who also hailed from the Azores. Much of their property was originally settled in the 1870s by Job and Serena Waters Heath. Serena was the sister of William Waters Sr. and a native of New Bedford, Massachusetts. All that remains of the improvements seen in this picture are a few eucalyptus trees. (Big Sur Historical Society.)

Tony and Margaret Brazil are shown here on their wedding day, July 22, 1929. Margaret, the daughter of Alvin and Kate Pfeiffer Dani, was born in 1912 at her father's ranch on the Little Sur. Tony, born in 1904 at the family spread, was a lifelong rancher at the home place. Margaret is still referred to as an expert horsewoman, one of the best on the coast. They raised two children on the ranch, Dani Sue Lopez and John David Cline Brazil, their grandniece and nephew, respectively. In the late 1970s the Brazils sold the ranch to famed television personality Allen Funt, creator of *Candid Camera.* In 2003 the property was added to Los Padres National Forest. (Courtesy Ewoldsen family.)

The Hoges lived along Bixby Creek, adjoining the Brazils to the south. Horace Hoge, a farmer born in Arkansas in 1872, was postmaster of the Sur Post Office (located at his ranch) from 1896 until it closed in 1913. Esther Pfeiffer Ewoldsen recalled that Harry Hoge, as she knew him, was "the slowest man anywhere around. It was said that if he went to the beach for abalones, the abalones would beat him back to the house." The property on which the ranch house was located, seen here c. 1920, had been acquired in 1890 as a cash sale by the U.S. government to Thomas Fussell, a woodsman born in Iowa in 1867. (Courtesy Pat Hathaway; 88-18-03.)

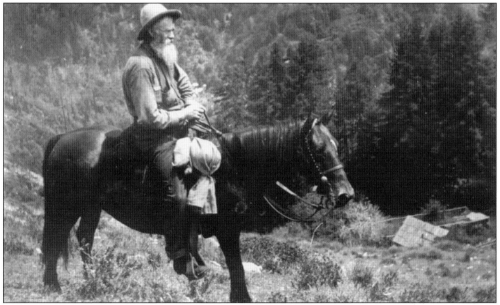

Thomas Jenkins, born in Massachusetts (or Indiana) in either 1854 or 1858 (existing records conflict), worked as a blacksmith in 1896 and was listed as a farm laborer in the 1900 census. His ranch was located on Long Ridge, on the north side of Bixby Canyon. When this photograph was taken by Louis S. Slevin on May 27, 1919, it was noted that Jenkins had resided on Long Ridge for some 26 years and had previously lived in Palo Colorado Canyon. The Jenkins property had originally been acquired as a cash sale by Edward Barth, who gained title to the government land in 1891. (Courtesy Mayo Hayes O'Donnell Library.)

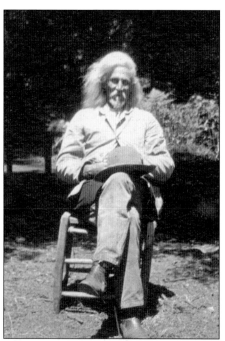

Alfred K. Clark, seen here in the 1920s, was listed in the voter register for 1896 as a 44-year-old rancher. Born in England, he became a U.S. citizen in 1871. "Al" Clark was a carpenter who helped I.N. Swetnam build his Palo Colorado home, and played banjo at local dances. Chase met him in 1911 and described "his bright blue eyes, skin originally ruddy but now tanned . . . and a shock of long white hair . . ." Clark was searching for silver on the slopes of Pico Blanco, using his theory "that every metal has a father and a mother." Although apparently impoverished, Chase recounted that Clark "cared nothing for actual money, being content with knowing that he could at any time procure it." (Courtesy Norma Graham.)

The daughters of Albert Geer Sr. and his wife, Alvina Dani Geer, pictured here c. 1934, are, from left to right, June, Betty, Ruby, and Elsie Geer. Alvina, the daughter of Alvin and Mary Ellen Pfeiffer Dani, was born on the Little Sur. Her daughters are depicted sitting on the porch of the old Al Clark homestead on the South Fork of the Little Sur. In his later years Clark was cared for by the Geers, and in return Clark bequeathed them his ranch, now owned by a mining company seeking to extract what is believed to be the purest deposit of limestone in California. (Courtesy Alice Pfeiffer Kelch.)

Joseph Gschwend of the lower Little Sur is shown here in a photograph by Lou G. Hare *c*. 1900. A Swiss native born *c*. 1833, he called his ranch "Little Switzerland." Gschwend was a farmer who was listed in the 1896 voter register as having been naturalized in 1873; he was also known as a woodsman and surveyor. When the County of Monterey extended the old Coast Road south toward the forks of the Little Sur, it was Gschwend who surveyed the route. The particular stretch of road laid out by Gschwend was (and still is) particularly serpentine, and it has been said that the worthy surveyor was attempting to inscribe his own signature upon the landscape. (Courtesy John and Helenka family collection.)

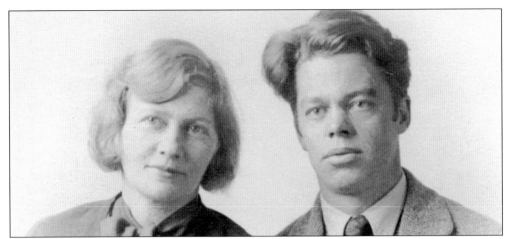

Harry Dick and Lillian Bos Ross are pictured here in 1930. The Rosses first encountered Big Sur in 1924, when they hiked up the Coast Trail from San Simeon, where Harry Dick (1899–1989) had been working as a tile-setter at William Randolph Hearst's estate. The Rosses lived for many years in Big Sur, where Lillian (1890–1960), known to her friends as "Shanagolden," wrote her best-selling novel *The Stranger,* published in 1942. The Rosses represented a new sort of pioneer in the Big Sur region: the kind who came to savor the compelling beauty of the Santa Lucia coastline. In the late 1940s the Rosses bought land on Partington Ridge, which by then had developed into a vibrant neighborhood of artists, writers, and other assorted bohemians. (Big Sur Historical Society.)

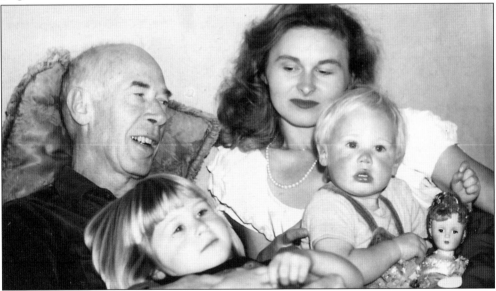

Henry Miller (1891–1980) and family, shown here on Christmas Day, 1950, include, in front, children Valentine (left), and Tony, on the lap of their mother, Lepska. Miller became famous after the publication of *Tropic of Cancer* in 1934. He arrived in Big Sur in 1944 to visit the Rosses and stayed for the next 18 years. Miller was a magnet for others seeking to emulate his lifestyle, and is often given credit for establishing the Big Sur "artist colony." Born in New York City, Miller lived for many years in France before a hasty departure during World War II. Prior to the lifting of the U.S. ban on his *Tropics* books in 1961, the poverty-stricken Miller paid his bills by selling his now-priceless watercolors. (Courtesy Henry Miller Library.)

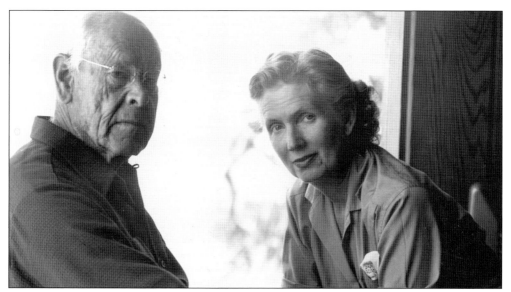

Coastlands resident William Colby (1875–1964) is shown here with his wife, the former Helen Flemming (1904–1980). Will Colby graduated from Hastings College of Law in 1898, and that summer began working for the Sierra Club at Yosemite. He later served on the board of directors (1900–1949), and was honorary president from 1950 until his death. Colby, a prominent mining attorney, also believed in preserving our nation's unspoiled landscapes. He was a close friend of Sierra Club founder John Muir, who once stated that Colby (responsible for the creation of Kings Canyon National Park) was "the only one of all the club who stood by me in downright fighting." Colby's first wife died in 1902; in 1951 he married Helen, the painter (and teacher of painters) who later was wed to Harry Dick Ross. (Big Sur Historical Society.)

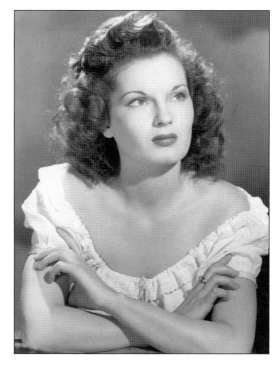

Eve Miller Ross (1924–1966) is shown in a publicity photograph from the 1940s. Eve, a champion swimmer, had command of five languages and was an authority on the works of playwright Henrik Ibsen. Eve enjoyed a varied career in drama, with roles in radio theater and stage productions, and also put in a stint as a chorus girl in Earl Carrol's *Vanities* during the last days of vaudeville. She came to visit Henry Miller on Partington Ridge and remained as his wife. They later separated, and Eve married Harry Dick Ross, who happened to live next door. Eve developed as an innovative artist in charcoal and oils under the tutelage of Ephraim Doner and Helen Colby. (Big Sur Historical Society.)

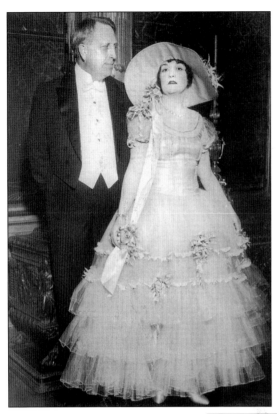

Newspaper publisher William Randolph Hearst (1863–1951) is shown here with his wife, Millicent, in 1927. He aggressively (some say ruthlessly) obtained land from local ranchers, although the Harlan and Evans families resisted, containing Hearst south of Limekiln Creek on the South Coast. Hearst's ambition was to own all the land between Cambria and Carmel. While he fell short of his goal, he still held title to 240,000 acres in the area. Most of his domain, including present-day Fort Hunter Liggett and adjoining national forest lands, was transferred to the government after Hearst went bankrupt in the 1930s; thus residents south of Lucia live on property he never acquired. His famed "Hearst Castle" at San Simeon, now a state park, opened to the public in 1958. (Courtesy *San Francisco Examiner*.)

Wilber Harlan (left) and Edward S. Moore were photographed at the Harlan home by Hester Harlan, *c.* 1934. Moore had major holdings in the National Biscuit Company and Pacific Telephone and Telegraph, and in 1931 purchased land in and around Big Creek, thus becoming the next-door neighbor of Wilber Harlan. Moore, in the tradition of Hearst, vainly coveted the Harlan lands, hoping to add them to his 8,000-acre Circle M Ranch (the "M" stood for Moore). In 1944 he sold the place to entertainer John Nesbitt, "The Golden Voice of Radio." Later divided, its components today form Landels-Hill Big Creek Reserve, the Immaculate Heart Hermitage, and the Gamboa Point Properties owned by the family of the late David Packard. (Courtesy Stan Harlan.)

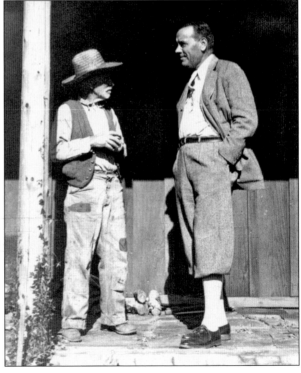

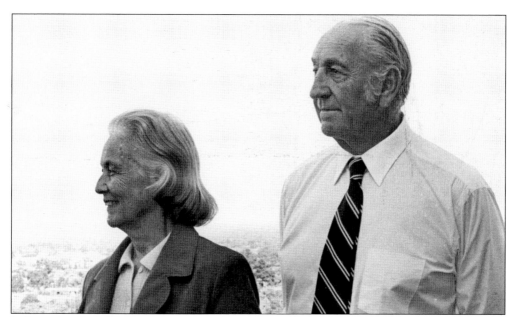

Industrialist David Packard (1912–1996) and his wife, Lucile, were photographed in 1982 by Ann Duwe. In 1979 the Packards purchased some 3,000 acres of the old Circle M Ranch, placing the land into a protected status; they later made the property available to researchers at the adjoining 3,900-acre Landels-Hill Big Creek Reserve, creating a diverse living laboratory for the study of natural sciences. In 1939 Packard and William Hewlett founded the Hewlett-Packard Corporation, pioneers in the field of precision instruments and computer technology. Lucile Salter Packard (1914–1987), known as a generous supporter of charities, was the principal donor of funds that allowed the Big Sur community to construct the present branch of the Monterey County Free Library in 1987. (Courtesy Julian Lopez.)

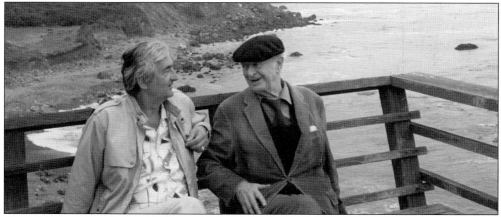

Chemist Werner Baumgartner (left) meets with Dr. Linus C. Pauling at Pauling's Salmon Creek ranch in May 1987. Born in Portland, Oregon, Pauling (1902–1994) was the first to be awarded two unshared Nobel Prizes in separate fields: in 1954 he won in chemistry for his work on chemical bonds, and in 1962 took the Nobel Peace Prize after publicizing the threats imposed by nuclear weapons testing. In 1955 Pauling and his wife, Ava Helen, with the money from his chemistry prize, purchased the ranch at Salmon Creek from homesteader Ray Evans. The famed scientist ran up to a dozen cattle on the place, mostly to reduce fire hazard. (Courtesy Ava Helen and Linus Pauling Papers, Special Collections, Oregon State University.)

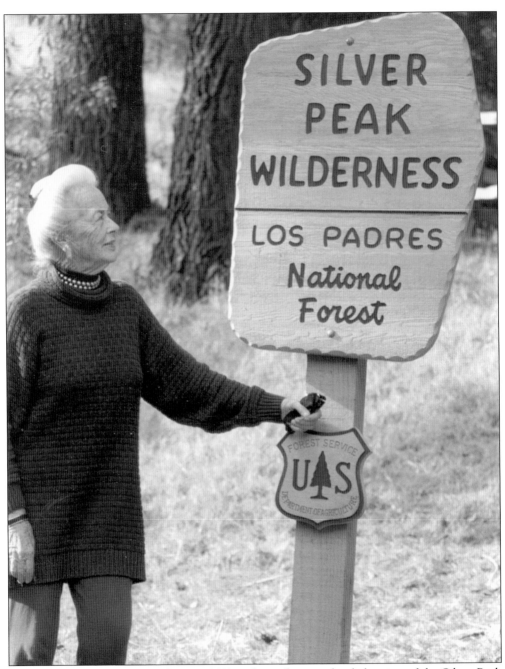

Margaret Wentworth Owings (1913–1999) is shown here at the dedication of the Silver Peak Wilderness Area at Salmon Creek on November 20, 1993. In 1952 Owings and her husband, architect Nathaniel A. Owings (of the firm Skidmore, Owings and Merrill), purchased land at Grimes Point, later building a showplace home they called "Wild Bird." Margaret Owings, a talented artist, was a noted conservationist, campaigning for the protection of sea lions and the southern sea otter, marine mammals that were very much a part of her experience in Big Sur. In 1968 she founded the Friends of the Sea Otter, at a time when proposals were being made to kill otters that interfered with abalone harvesting. (Courtesy Mary Wright.)

Two

INDUSTRY AND COMMERCE

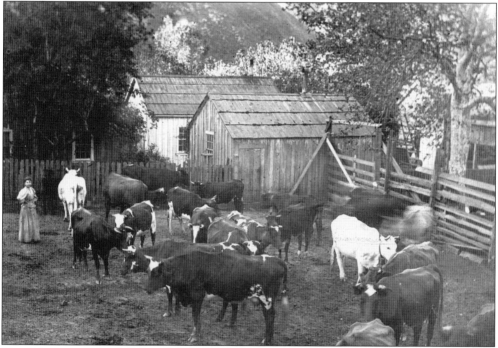

Kate Pfeiffer is shown here at the Pfeiffer Ranch in Sycamore Canyon in the late 1800s. Cattle ranching was the real mainstay of the economy in Big Sur, although hogs and a few sheep were also raised. The Pfeiffers had to protect their livestock from predators, primarily the California grizzly bear, a huge carnivore that was a difficult match for the firearms available to settlers. The Pfeiffers discovered the best way to eliminate the grizzlies: a lethal dose of strychnine in a ball of suet was hung from a branch of a tree, low enough for a bear to reach, but high enough to avoid poisoning children, dogs, etc. As isolated as the region was in the early days, local industry needed to include nearly every occupation. Besides stock raisers and cattle drovers, the area supported farmers, millers, miners, muleteers, seamstresses, hunters, school teachers, teamsters, storekeepers, beekeepers, lighthouse keepers, bar keepers, woodsmen, blacksmiths, furniture makers, fishermen, farm laborers, dairy workers, woodcutters, road makers, and more. (Frank Trotter Collection, Big Sur Historical Society.)

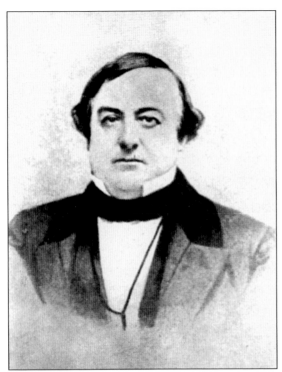

Juan Bautista Alvarado (1809–1882), seen in this 1854 portrait by C.C. Pierce, was the first European landowner on the Big Sur Coast. He began stocking the pastures of Rancho El Sur with cattle and horses in the late 1820s, receiving title to the land grant in 1834. Alvarado's mother, María Josefa Vallejo de Alvarado, was the sister of J.B.R. Cooper's wife, Encarnación, and in 1840 Alvarado traded Rancho El Sur to his uncle in return for lands in the Salinas Valley. Alvarado was governor of Alta California from 1836 to 1842 during the Mexican régime, and attained the rank of colonel, serving under the command of another uncle, General Mariano Guadalupe Vallejo, during Mexico's war with the United States. (Courtesy California History Room, Monterey Public Library.)

During the Cooper family's ownership, Rancho El Sur raised cattle for dairy purposes as well as for hides and meat. This photo, taken June 15, 1939, shows the dairy barn once located in Creamery Meadow, near the Big Sur river mouth and now a part of Andrew Molera State Park. Milk, a valuable but perishable commodity, could be made into cheese, and Capt. Cooper's records indicate that this industry began on Rancho El Sur as early as the 1850s. It is said that Cooper's dairy workers used jacks to press whey from the curds; since the resultant product was sold in Monterey, it naturally became known as Monterey jack cheese. (Cooper-Molera Collection; courtesy California Department of Parks and Recreation.)

These buildings, identified as a storehouse (left) and residence (right), were located near today's walk-in campground at Andrew Molera State Park. In the foreground in this early 20th-century photograph the flood plain of the Big Sur River can be seen. Many workers and their families lived on the ranch, including a foreman, cowhands, and farm and dairy laborers. Near the turn of the last century the foreman was Joseph William Post Sr., son of William Brainard Post; J.W. Post's brother, Frank, also worked there during this period. A foreman from the early 1900s, J.C. Anthony, later became a prominent builder in Monterey. (Cooper-Molera Collection; courtesy California Department of Parks and Recreation.)

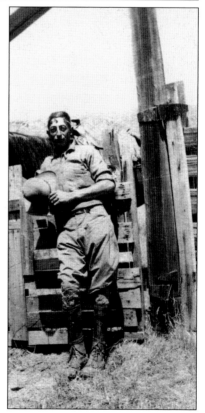

Pictured here is Molera Ranch cheese maker James Artellan, c. 1920. Artellan, born in March 1894, was the son of Juan Artellan, a cattle drover, and his wife, the former Matilde Escobar, remembered to this very day for her delicious tamales. Artellan grew up on the Molera Ranch (now Andrew Molera State Park), one of 19 children that his father sired by at least two wives. Juan was a son of the colorful Pierre Artellan, said to have been a French pirate who sailed from Bordeaux in 1835 and jumped ship in Monterey. (Joy Anthony MacLean Collection; courtesy California Department of Parks and Recreation.)

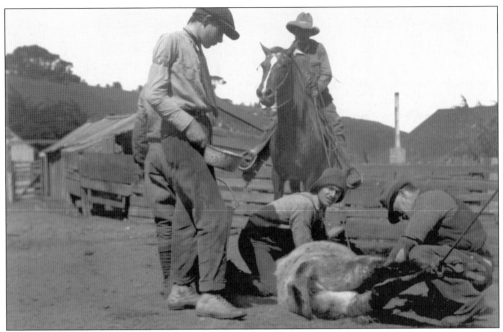

In the spring of every year, ranchers rounded up unmarked calves for branding. At this time the male calves were castrated, as is depicted in this photo from the 1920s at the Victorine Ranch south of Malpaso Canyon. One cowhand holds the calf steady, assisted by mounted hands (center, and out of the picture to the right) who have lassoed the animal. At the right is a ranch hand in the process of neutering the calf, while a youth (left) waits with a pan to hold the organs until they are barbequed, as they are a delicacy not to be wasted. (Courtesy Walter Victorine.)

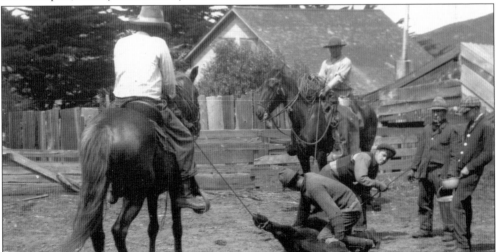

At another 1920s round-up on the Victorine Ranch, a calf is shown being restrained during the branding process. Here, an iron bearing the Victorine brand, previously heated in a fire, sears the hide of the calf. Nowadays the marking of calves is usually accomplished by clipping an ear, or attaching a plastic tag to one or both ears. Although the other workers are unidentified, Joseph Victorine Sr., the owner of the ranch, appears second from right. Little remains of the Victorine Ranch today except the remains of the chimneys from the dairy building and the house, which burned to the ground in the mid-1940s. (Courtesy Walter Victorine.)

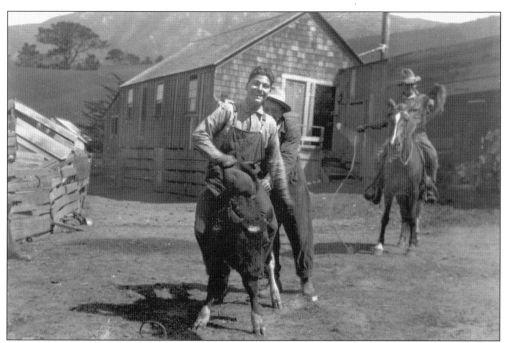

All work and no play is no way to run a ranch: Ernest Victorine rides a calf during a branding at his ranch in the early 1920s. The Victorines, a popular family, extended their hospitality to ranchers bringing their herds to Monterey to be sold. Locals from points south could always count on spending the last night of their cattle drive at the Victorine place, where market steers could be corralled overnight and the drovers could spend the night in a small bunkhouse. The ranch property now adjoins Garrapata State Park, created in 1983 and consisting of some 3,000 acres extending from the hills seen in the background of this picture south to Garrapata Creek. (Courtesy Walter Victorine.)

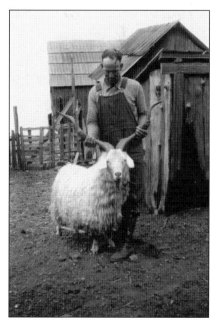

George A. Harlan displays a prized Angora goat at his Lopez Point ranch, north of Lucia, in this photo from 1925. The land on which these structures are seen is presently occupied by Highway 1. George Marion Harlan, the elder half-brother of George A. Harlan's father Wilber, homesteaded a 160-acre claim in the Limekiln Creek watershed, receiving patent to the land in 1908; his sons Wilbert, Claude, and Roy were brought up there. George M. Harlan raised Angora goats at this ranch, near the site of today's aptly-named Goat Camp in Los Padres National Forest. After he died in 1921 his nephew, George A. Harlan, fell heir to some of these animals. (Courtesy Stan Harlan.)

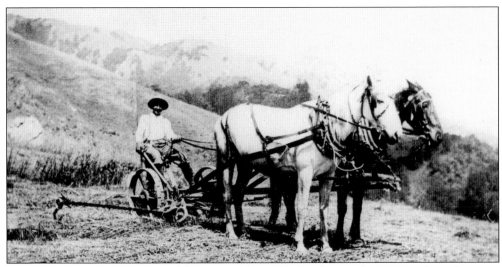

In the old days hay, used to feed horses, cattle, and other livestock, was raised on the more prosperous ranches, although ranchers today usually buy hay grown elsewhere. Livestock were allowed to graze in the open pastures as much as possible, with hay being cut, cured, and stored in order to feed dairy stock and horses used for riding, packing, and for harness work such as plowing and pulling wagons. In this picture, a worker at the old Post Ranch cuts hay in a field located at today's Ventana Resort; the hills behind what is now Nepenthe loom in the background. (Big Sur Historical Society.)

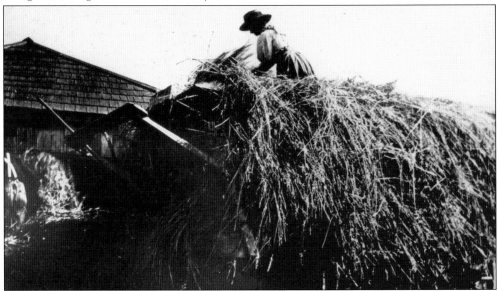

In this photo, a woman assists in storing hay at the Post barn, which was torn down in the 1920s to make room for Highway 1. Oat and barley hay was commonly raised, although alfalfa, which requires irrigation, was seldom grown. Permanent pasture was sometimes installed, although this demanded heavy irrigation, and few had access to adequate water for this purpose. However, the Molera Ranch, located along the perennial waters of the Big Sur River, was the site of irrigated pasture for the use of its dairy herd. Now considered a historic resource, the remains of irrigation canals can still be seen at Creamery Meadow within Andrew Molera State Park. (Big Sur Historical Society.)

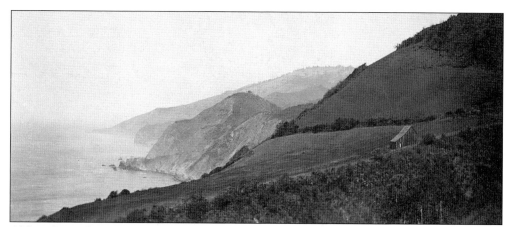

Although much of the coastal landscape was too steep for large-scale farming, every rancher raised vegetables and fruit to some extent, and what wasn't used in the home could be sold or exchanged with neighbors. The farm of William Hubble, shown here in a John Little photo from the early 1900s, supplied produce to local families. Hubble homesteaded his place, south of Limekiln Creek, in 1894, making use of the rich soil found on the relatively level terrain seen in this picture. Typical of so many places on the coast, the Hubble farm has virtually disappeared, having been reclaimed by the native coastal scrub once laboriously cleared by the Hubble family. (Courtesy Jeannine Little Karnes.)

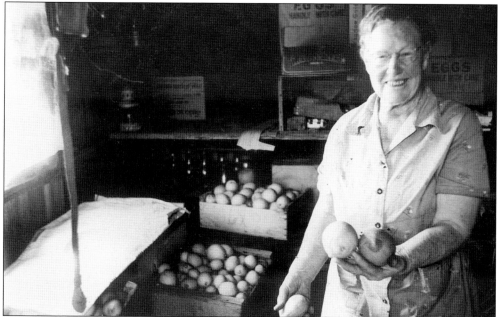

Lulu May Harlan displays a harvest of pears in her kitchen at the Harlan Ranch at Lucia. Lulu, who lived on the home place all her long life, was a prolific gardener. What wasn't immediately consumed was put up in jars; this August 1961 picture by Dick Rowan was taken during one of her canning stints. She homesteaded a parcel of her own, obtaining a patent in 1919, and was postmaster of the Lucia Post Office from 1915 to 1932. Lulu Harlan also operated Lucia Lodge for some 17 years. During this time, travelers could feast on her homemade desserts, among the best of which was her lemon meringue pie, baked with home-grown lemons. (Harbick Collection; courtesy California History Room, Monterey Public Library.)

James M. Krenkel, perhaps best known as a gold miner, stands in the vegetable garden at his ranch above Alder Creek in Los Burros Mining District in this photo from the late 1930s. Besides growing corn and sunflowers, seen here, the Krenkels raised almost every other kind of fruit and vegetable. They were among the first Big Sur residents to try growing avocados, and trees planted nearly a century ago still bear prodigious amounts of fruit. The Krenkels had a vineyard as well, and trained one of their grapevines on a trellis that shaded the yard of their home, which is still standing and owned by James R. Krenkel, grandson of James M. and Margaret Krenkel. (Courtesy James R. Krenkel.)

The abundant wildlife on the Big Sur Coast often made for a challenge to the stock raiser and farmer. The trapping of animals for their fur reduced depredation and generated cash, as the pelts could be sold for a decent profit. Seen here at the Krenkel Ranch, c. 1926, are, from left to right, James and Margaret's children Lillian, Tuck, and Hal Krenkel; their harvest includes pelts of gray foxes and raccoons. In 1924, while walking the Big Sur Coast, Harry Dick and Lillian Ross visited the Krenkels. Lillian Ross, delighted to meet Lillian Krenkel, wrote in her journal that the child was wearing "overalls and a cap like her brother and was busy dragging around traps." (Courtesy James R. Krenkel.)

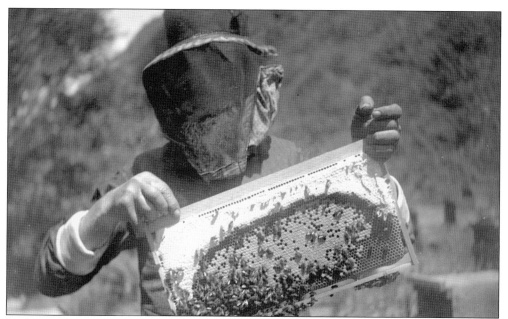

Beekeeper Isaac Newton Swetnam is shown examining a frame of brood comb, taken from a hive at his apiary in Garrapata Canyon, c. 1900. This was the property to which the Swetnam family moved in the late 1880s after having settled on the North Fork of the Little Sur. Swetnam's sage honey was of the highest quality. This was an important crop for many local ranchers, as honey could be extracted and stored indefinitely—especially sage honey, which resists crystallization. Swetnam's son-in-law John Pfeiffer raised bees, as did Pfeiffer's neighbors, the Hopkens. Edward Grimes kept bees in the 1800s, and his grandson Franklin Peace continues the tradition to this day. (Courtesy California History Room, Monterey Public Library.)

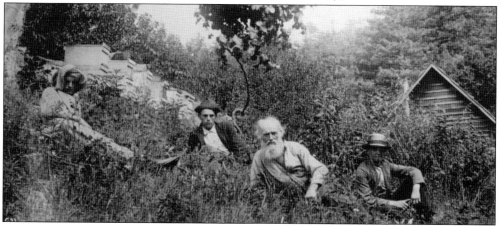

This photo of the Vandall Bee Ranch in Palo Colorado Canyon was taken in the early 1900s by Louis S. Slevin. Shown from left to right are John Vandall, his brother Ned, their father Bartholomew Columbus Vandall, and Frank Green. B.C. Vandall, born in 1824, owned a 160-acre farm adjoining that of Edmund Sterritt. Years later his neighbor, Elfrieda Swetnam Hayes, recalled Vandall and his orchard. "Mr. Vandall loved his trees and was a dear man. He had the only cherry trees around and would invite us children up to his place and let us pick them. He said if anyone cut his trees after he died, he would come back and haunt them." (Courtesy Monterey County Free Libraries, Salinas, California.)

The major timber resource of the Big Sur region was its forest of coast redwoods. These huge trees, reaching more than 360 feet in height in Northern California, are found here at the south end of their range; the southernmost naturally occurring coast redwood stand is in the Soda Springs watershed just north of the Monterey–San Luis Obispo county line. The massive tree in this photograph, taken in 1900, was probably growing in the Big Sur drainage. Shown from left to right are Louisa (Mrs. Lou G.) Hare, Lou G. Hare (holding their son Evatt), and their daughter Dorothy, held by babysitter Chona Sanchez. (Courtesy John and Helenka Frost family collection.)

Until the advent of the chain saw in Big Sur after World War II, redwoods were generally harvested using two-man cross-cut saws. Two cuts were required: the first was most often made with an axe, as a relatively wide notch was required to allow the tree to safely drop. The second cut, which felled the tree, brought into play the cross-cut saw, sometimes called a "misery whip," reflecting the amount of labor involved to fell a large tree. Prior to the construction of sawmills in Big Sur, only trees with straight grain were taken, as finishing work was done by splitting the logs with mauls, wedges, and froes. The resulting products included railroad ties, shakes, fence posts, boards, and grape stakes. (Courtesy Ewoldsen family.)

This sawmill was located along the Big Sur River at the John Pfeiffer ranch, now within Pfeiffer Big Sur State Park. Originally built by the Ventana Power Company, the mill (on the south side of the river) was operated by a steam-powered "donkey engine" fueled by firewood. On the north side of the river were located the company's store and office building, bunk-house, cook-house and dining room, workers' cottages, and barn. The company went bankrupt after the 1906 San Francisco earthquake and fire; later, John Pfeiffer's wife, Florence, ran the mill, using the lumber to build many of the cabins that were rented by vacationers at Pfeiffer's Ranch Resort, predecessor of the state park. (Courtesy Ewoldsen family.)

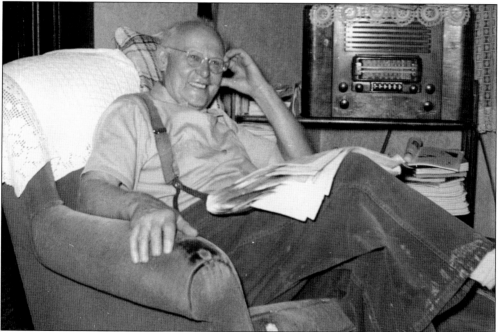

Edward R. Sans (1875–1959) operated one of several sawmills in Mill Creek on the South Coast of Big Sur. He engaged in this enterprise from about 1900 to 1910, having bought the land and its redwoods from Polk Fancher. Edward's parents were Charles and Sarah Sans; in 1870 Charles married Sarah E. Ray, daughter of James Ezekiel and Lavina Thomas Ray. Her family had come to California's gold country in 1849, later settling in the Reliz Canyon area of the Arroyo Seco; other members of the Ray family homesteaded in the Bryson country in south Monterey County. Edward Sans married Lydia Rich in 1894; they had six children, one of whom, Mabel, married South Coast rancher Ed Plaskett. (Courtesy Judy Smith.)

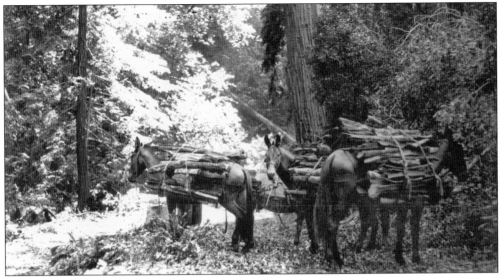

Another major forest product of the Big Sur Coast was the bark of tan oak trees. High in tannic acid, the bark was in demand for the curing of leather. To harvest the bark, the trees were felled and the bark stripped from the trunks. After being allowed to dry, sections were packed onto mules, as shown in this 1920 scene, photographed by C.B. Clark. If the terrain permitted, the bark would be loaded directly onto sleds called "go-devils," or wagons. The bark was then transported to one of many California tanneries, especially those of the Kron and Eberhard Tanning Company, which also owned large tracts of forest land in Big Sur. Until roads were improved in the area, most bark was shipped by sea. (Courtesy Pat Hathaway; 89-023-0250).

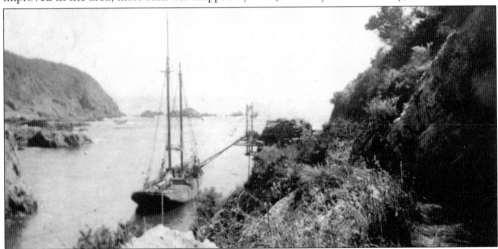

Seaview Landing is pictured here c. 1900. The schooner taking on a load of tan bark is believed to be the *Confianza*, which plied the Big Sur Coast for many years. John Partington, with partners Bert Stevens and James West, constructed the landing; it is usually called Partington Landing, but its builders named it after Partington's Seaview Ranch. Wagon and sled roads led down to the landing, which was located in a narrow cove. To reach it, a 116-foot tunnel was hacked through the intervening ridge. Such landings also served as shipping points for redwood and mining products, and even hogs; settlers also took advantage of coastwise shipping to import goods they couldn't produce themselves, such as barrels of flour, plowshares, barbed wire, and the like. (Big Sur Historical Society.)

Charles Bixby (1837–1915), for whom Bixby Canyon on the North Coast of Big Sur was named, came to the area in 1868. An ambitious entrepreneur who extended the coastal wagon road to his ranch, he also built Bixby Landing for the shipment of redwood and tan bark, as shown here in this C.W.J. Johnson photo, c. 1890. This particular installation was known as a chute landing, featuring an adjustable "clapper" at the lower end of the greased ramp. Lumber placed at the top was allowed to slide down to the clapper, which was raised or lowered by a "clapperman" to control the flow of boards, etc., onto the ship's deck. Although most landings were operated during the summer when seas were calmest, ships still needed to be secured by mooring to iron rings cemented into the shoreline bedrock. (Courtesy Pat Hathaway; 77-02-5.)

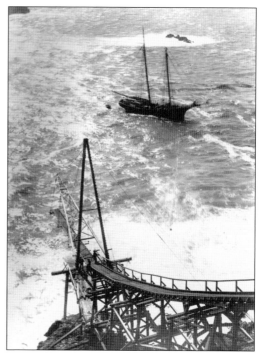

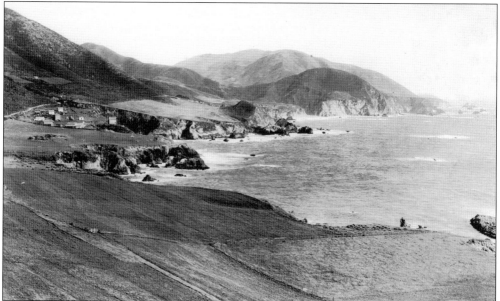

Notley's Landing at Palo Colorado Canyon, established by brothers William and Godfrey Notley in the 1890s, is seen here in the early 1900s. During its heyday, Notley's Landing was an active village consisting of the manager's quarters, a dormitory for workers, a shingle mill, store, barns, and assorted sheds. From here redwood and tan bark were shipped, having been transported to the site by six-horse wagon teams, then loaded onto ships by means of a steam-powered cable system. This arrangement required waiting vessels to moor beneath a cable attached by a pulley to an offshore rock. Material was dropped onto the ship's deck from a platform suspended from the cable. (Courtesy Elizabeth Knerr.)

Mining was also part of Big Sur's early industry. Shown here is a view of the abandoned Malpaso coal mine, photographed by Louis S. Slevin in 1919. Located in upper Malpaso Canyon, the coal seam was discovered in 1874. It became the property of the Carmelo Coal Company in 1888, the same year that title was cleared for Rancho San José y Sur Chiquito. It was no coincidence that this company's owners were among the principal claimants to the land grant upon which the mine was situated. Its low-grade coal was transported several miles north to a landing built in 1891 at the aptly named Coal Chute Point, now within Point Lobos State Reserve. (Courtesy Monterey County Free Libraries, Salinas, California.)

Limestone was used to manufacture slaked lime, the primary component of cement. Seen here are the limekilns in Bixby Canyon, c. 1920. In order to purify limestone, a process known as calcining or slaking, the limestone had to be heated in kilns such as these. Firewood and limestone were dumped into the tops of the kilns, and ignited from below. After several days of slow burning, controlled by regulating the flow of air into the kilns, the resulting lime was packed into barrels for shipment from Bixby Landing. At Limekiln Canyon on Big Sur's South Coast, a similar operation was conducted in the 1880s, with lime being shipped from Rockland Landing, now within Limekiln State Park. (Big Sur Historical Society.)

The Bixby Canyon limekiln operation was owned by the Monterey Lime Company, which bought out Charles Bixby's holdings in 1904. A thriving community was established adjoining the site of the kilns at Mill Hill far up Bixby Canyon, which in those days was usually called Mill Canyon (named for Bixby's sawmill, and not to be confused with Mill Canyon on the South Coast). Seen here on the rocky shore at the foot of Bixby Landing c. 1910, are, from left to right, Mr. Matsumoto (in charge of the landing warehouse), Ann Duffy, Sam Trotter, and Frank D. Shields (Monterey Lime Company manager). Duffy was a houseguest of Mr. Shields, who lived at Mill Hill. (Courtesy Pat Hathaway; 74-05-1.)

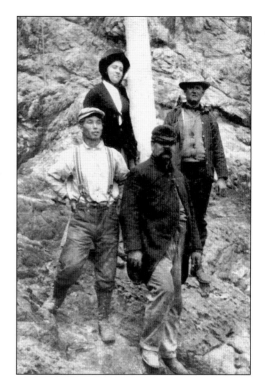

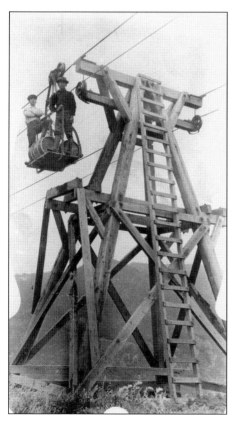

Barrels of lime were transported to Bixby Landing by means of a high-wire tramway, seen here c. 1910. Operated by donkey engine, this high-tech system was suspended from derricks constructed along the spine of Long Ridge and terminating at Bixby Landing. A story told concerning the marriage of a limekiln worker holds that, after the ceremony at Mill Hill, the newlyweds were offered a ride in the tram. While the car in which they were riding was perched hundreds of feet over Bixby Canyon, the operator cut the engine, leaving the couple dangling in the breeze overnight. The Mill Hill settlement was accessed by a wagon road that made some 22 crossings of Bixby Creek. When flooding in the 1910–1911 winter destroyed the road, Monterey Lime Company went out of business. (Courtesy Pat Hathaway; 74-05-6.)

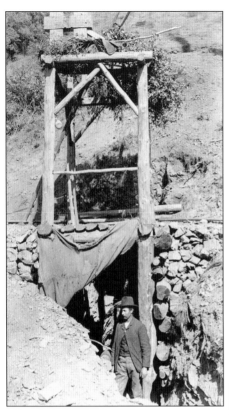

Gold was the most important mining resource of the Big Sur Coast. Seen here *c*. 1889 is William D. Cruikshank (1856–1937) at the discovery shaft of his Last Chance Mine, the claim that set off the South Coast gold rush of 1887. Gold had been found at nearby Jolon as early as 1850, and in 1875 locals organized Los Burros Mining District, which included the Alder Creek location of the Last Chance Mine. The boundary of the district extended from the mouth of San Carpóforo Creek north to Pacific Valley, east to the Nacimiento River (in today's Fort Hunter Liggett), down the Nacimiento to the mouth of Los Burros Creek, and west to the point of beginning. (Photo by Max Fischer, Barkle Collection; courtesy California History Room, Monterey Public Library.)

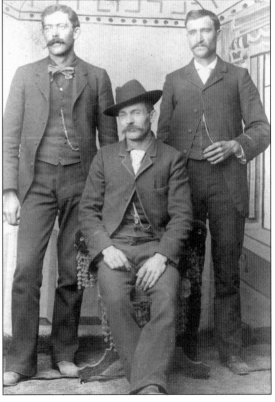

Three gold miners from Los Burros, pictured here *c*. 1890, from left to right, are Stan Hill, W.D. Cruikshank, and James Munroe Krenkel. Cruikshank made his discovery on April 7, 1887, later taking on partner Stan Hill. In 1889 Cruikshank sold the Last Chance to a company owned by T.A. Bell; after Bell's death in 1892, Cruikshank and Krenkel leased back the mine and worked it until 1901. During this period, the pair extracted some $14,000 worth of gold from ore that assayed at $40 to $50 per ton. In 1908 the Last Chance was sold to the Buclimo Mining Company. (Courtesy James R. Krenkel.)

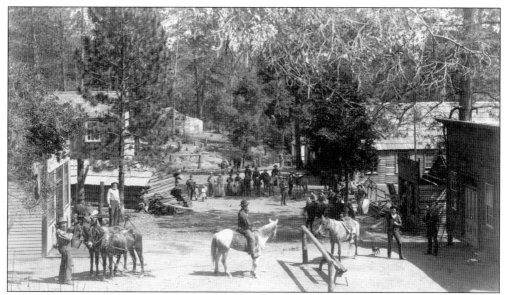

Pictured here is the town of Manchester, near the Last Chance Mine in the heart of Los Burros Mining District, c. 1889. With a population of 125–150, the town sprang up after Cruikshank's 1887 strike, and consisted of two general stores, a post office, restaurant, a number of saloons, and a dance hall. Although published accounts vary, it seems that in the 1890s the entire town was destroyed overnight by fire after residents loaded too much fuel into a wood-burning stove. Nothing is to be seen today of the original town; even the ponderosa pines that graced the settlement are gone. (Photo by Max Fischer, Barkle Collection; courtesy California History Room, Monterey Public Library.)

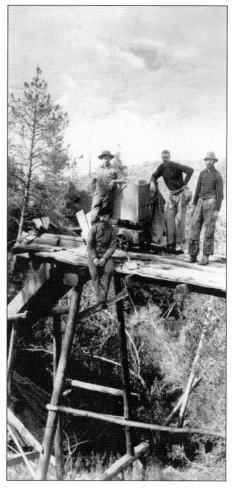

Perched on a trestle in this c. 1889 photo are four miners at Los Burros. One miner leans on a cart loaded with gold ore, ready to be processed in the stamp mill located below, at the left of the picture. Although Los Burros gold could be found in stream gravels, known as "placer deposits" (from the Spanish word for sandbank), much of the activity centered around lode deposits, which called for "hard-rock" mining. The ore thus derived was crushed in stamp mills and purified using mercury, another metal found within the district. (Photo by Max Fischer, Barkle Collection; courtesy California History Room, Monterey Public Library.)

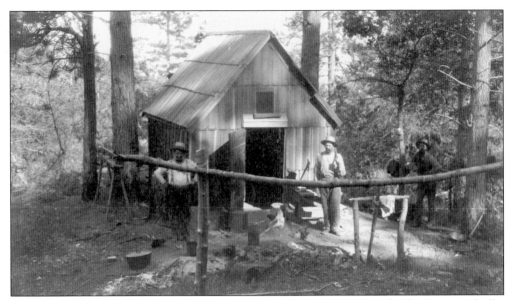

The office of the Melville Mining Company is pictured here c. 1889. Founded by Henry Melville, the office was situated on Gold Ridge, dividing Alder Creek from Willow Creek to the north. Melville (1843–1933) was the former owner of the Utanic Copper Mines in today's Pinnacles National Monument east of the Salinas Valley. Melville married Mary Pugh, daughter of James P. Pugh, a Soledad area rancher. Kenneth Melville, the last surviving child of Henry and Mary Melville, died in 1997 at the age of 98. (Photo by Max Fischer, Barkle Collection; courtesy California History Room, Monterey Public Library.)

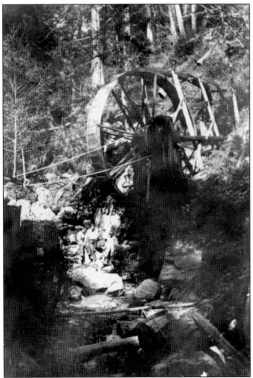

This overshot waterwheel, some 30 feet in diameter, dwarfs the unidentified group of people beneath it in this c. 1900 photo. The wheel powered belts, seen crossing the creek, that turned the Grizzly Mine's arrastra (from the Spanish *arrastrar*, meaning "to drag"), consisting of a circular pit in which a heavy crusher was drawn over the ore. However, the wheel was abandoned late in 1890 when the water supplying it became insufficient. The Grizzly produced some $9,515 worth of gold and $33 worth of silver in 1890 and from 1902 to 1904. The mine had been located in 1889 and boasted some 1,000 feet of tunnels by 1903. Situated along Alder Creek, the wheel was destroyed in the Buckeye Fire of 1970. (Courtesy James R. Krenkel.)

John D. Cruikshank, a nephew of W.T. Cruikshank, is seen at McNeil's Rest in this photo from the 1930s. Although little is known of the identity of McNeil, mining records indicate that one J.H. McNeil worked the Lucky Jim placer deposit in 1912, obtaining 6.7 ounces of gold and 2 ounces of silver. From 1913 to 1914, F.M. Plaskett worked the Lilac claim under the name of Blanco (or Blanche) McNeil; a total of 319 ounces of gold and 55 ounces of silver were extracted from its lode deposits. The 2,000-plus names of Los Burros mines were often colorful; of these, Black Fir, Brewery, Condor Group, Fighting Chance, First Chance, Hobbit, Humbug, Lucky Cuss, None Such, Old Man of the Mountains, Pansy, Queen Hattie, and Scorpion are only a few. (Courtesy James R. Krenkel.)

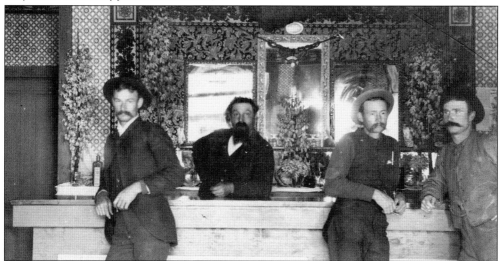

Three prospectors and their host lean on the bar at Davis' Saloon at Manchester in this *c.* 1889 photo. The boomtown had a rough-and-ready reputation, although another aspect was related by Alice Eastwood, the botanist from the California Academy of Sciences in San Francisco, who visited Los Burros in 1893. Eastwood stayed with the Plaskett family and later wrote, "at Los Burros . . . a literary and debating society had been formed and the Plasketts belonged. There was also quite a good school library . . . " (Photo by Max Fischer, Barkle Collection; courtesy California History Room, Monterey Public Library.)

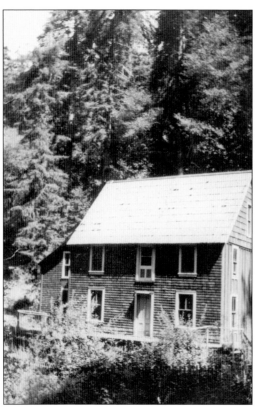

In the late 1800s people coming to Big Sur might be drawn to the area for reasons other than resource extraction or subsistence farming and ranching. The beauty of the coast, a valuable commodity in itself, gradually began to replace the other attractions of the region, and the tourist industry eventually became the major occupation of residents. Seen here c. 1900 is the Idlewild Hotel, a "family resort and camp ground" situated along the County Road beside the South Fork of the Little Sur River. In addition to camping, Idlewild offered hunting and trout fishing. The establishment was later moved to the North Fork, and by the 1920s Idlewild had acquired a reputation as the purveyor of bootleg alcohol. (Big Sur Historical Society.)

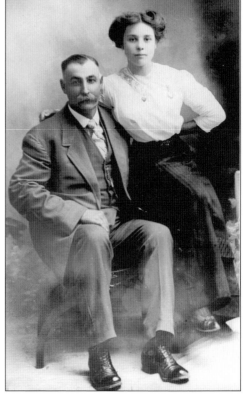

Old-timers recall that Idlewild was established by Charles Howland, pictured here with his daughter Sybil, c. 1915. Howland, born in March 1865, was enumerated as an assistant lighthouse keeper at Point Sur in the 1900 U.S. census. Sybil, born in 1892, and Howland's wife, Hattie, born in 1868, were not living at the lightstation in 1900, being listed in a separate household from Charles. Howland appears to have been associated with one W.T. Mitchell at Idlewild, as a brochure for the resort refers to Mitchell as the proprietor, c. 1900. Perhaps Howland was too busy at the lighthouse to take an active part in Idlewild's management. (Big Sur Historical Society.)

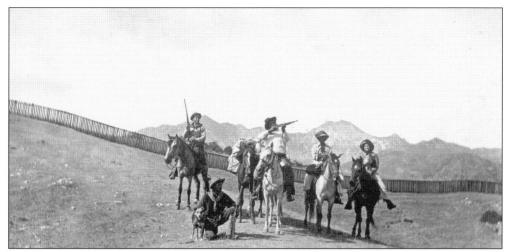

Members of the Post family were popular hunting guides for visitors to the Big Sur backcountry. Few locals were as familiar with the mountain trails as the Posts, and in 1916 the family obtained a government contract for construction of the Pine Ridge Trail in today's Ventana Wilderness Area of Los Padres National Forest. This trail is now one of the most widely used wilderness access routes on the Big Sur Coast. Seen here on the Coast Ridge near the summit of the Terrace Creek Trail, *c.* 1912, are, from left to right, Bob Grimes, his cousin J.W. Post Jr., J.W. Post Sr., Lizzie Post (wife of J.W. Sr.), and Bob Grimes's wife, Hattie. In the distance can be seen Kandlbinder Peak (behind Bob Grimes) and the Ventana Double Cone, at 4,863 feet (right center). (Courtesy Franklin Peace.)

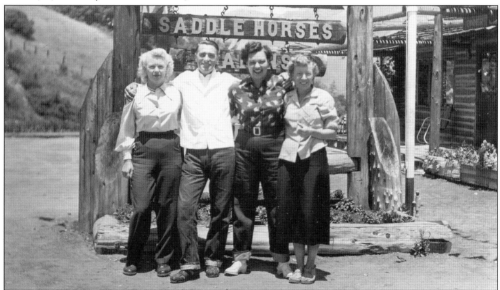

After Highway 1 was opened, in 1937, the Post family's Rancho Sierra Mar offered campsites, a restaurant, gas station, and horses for hire. The Posts's breakfast rides were especially popular, and followed the historic Coast Ridge Trail to the scenic spot seen in the previous photo. Pictured here are three unidentified friends of Mary Post (third from left). Mary, daughter of J.W. Post Jr. and his wife, the former Irene Frederick, later married Hugh Fleenor, and together they ran the Post family resort for many years. Born at the Post Ranch in 1922, Mary died there in July 1989; she will always be remembered for her open-handed generosity. (Courtesy J.W. Post III.)

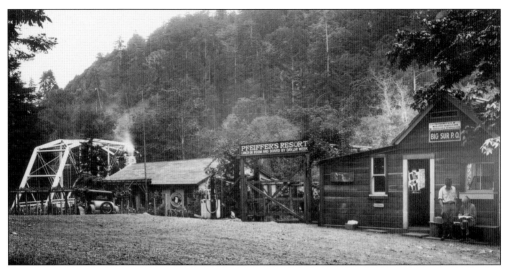

Pfeiffer's Ranch Resort was established by Florence Pfeiffer in 1908. She and John extended their hospitality to all who visited their home, located along the County Road in the Big Sur Valley. Many who invited themselves stayed for dinner, and next morning enjoyed one of Florence's hearty breakfasts. Florence finally drew the line and began charging travelers for food, lodging, and feed for their horses. "Strange to say," Florence wrote years later, "when the people had to pay, we had a far nicer class of guests . . . " Seen here is the resort, photographed by Lewis Josselyn on May 7, 1935, showing the location of the Big Sur Post Office (right) while Florence was the postmaster. (Courtesy Pat Hathaway; 71-01-BS-155).

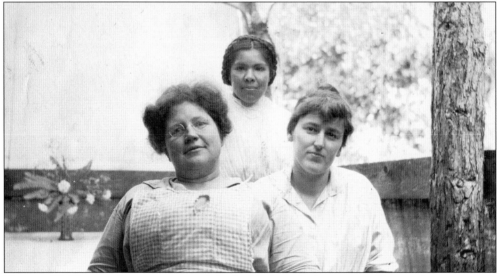

Florence Pfeiffer put a large crew to work in the kitchen, dining room, cabins, and campgrounds during the busy summer season. Seen here, c. 1920, from left to right, are Florence Pfeiffer, María Onesimo, and Florence Lial. María Onesimo, born in 1900, a descendant of Antonio Onesimo and thus a relative of Anselma Post, later married Pete Ramirez. Their children were Margaret, Alex, Pete Jr., and Vincent Ramirez. Florence Lial and her sisters worked many summers at Pfeiffer's Ranch Resort; her family owned much real estate in downtown Monterey, including the arena where bull and bear fights were staged in the 1800s. (Courtesy Ewoldsen family.)

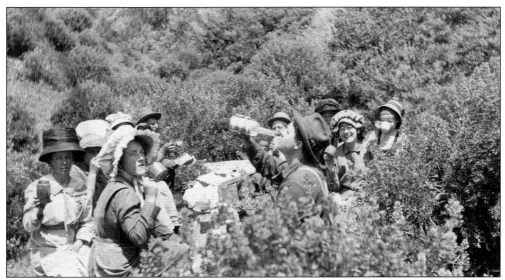

The Pfeiffers offered their guests hayrides and beach picnics. Seen here, *c.* 1915, is a group of picnickers at Pfeiffer Beach that includes Florence Pfeiffer's sister, Elfrieda (left foreground, wearing white bonnet), and Elfrieda's husband at the time, Bob Drinkwater (right foreground, imbibing from a bottle). The photograph documents a family pun, as all the folks are seen drinking water. At the close of her long life, Elfrieda Swetnam Hayes (her final married name) produced an important memoir that recounted much of the early history of the Palo Colorado Canyon area, where her family settled in the 1880s. (Courtesy Ewoldsen family.)

In the 1930s, as the construction of Highway 1 progressed, increasing pressure was placed on local residents to sell their land to tourism-related developers. John and Florence Pfeiffer resisted, and in December 1933, at the urging of Will Colby, they chose to sell a portion of their ranch to the State of California. Opened in 1934, today's Pfeiffer Big Sur State Park remains as a memorial to the family that cared so much for the area's natural beauty. Seen here is the first Big Sur Lodge, operated by a park concessionaire. This structure burned in the 1950s and was replaced by the present building. (Courtesy California History Room, Monterey Public Library.)

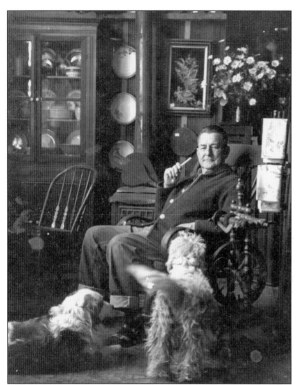

Helmuth Deetjen (1892–1972), a Norwegian immigrant who began visiting Big Sur in the 1920s, is seen here c. 1960 in a Brook Elgie portrait. A skilled carpenter, Deetjen had been working in Carmel, where he met his wife, Helen Haight, then employed as a private nurse. In 1936 the Deetjens bought a portion of the Castro Ranch, and Helmuth proceeded to build various structures in an architectural style reminiscent of his homeland. Barbara Blake began living there in 1939 and leased the Deetjen's barn, developing the place into a restaurant. Blake later built rooms for overnight rental. Today Deetjen's Big Sur Inn is run by a nonprofit corporation, and in 1990 the entire establishment was listed on the National Register of Historic Places. (Courtesy Big Sur Historical Society.)

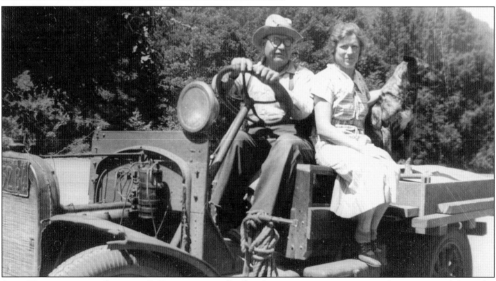

Sam Trotter is seen here with Doris Fee and Chief, c. 1934. In 1925, Fee (1906–1997) bought land in the Big Sur Valley with her father, soon opening Ripplewood Resort, which offered rental cabins along the river. After selling Ripplewood, Fee then founded Glen Oaks Motel next door; today both these businesses carry on the authentic Big Sur family-style resort tradition. Fee, a fine cellist, supported many local charities and was also a long-time member of Monterey County's land use advisory committee. Sam Trotter's hand-made vehicle, known to locals as "Whoopie," featured a Kissel frame and front axle, a four-cylinder Dodge motor and transmission, and a Cadillac rear end. (Courtesy Lillian Trotter Von Protz collection.)

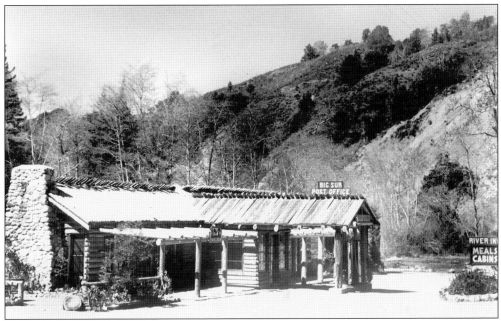

River Inn, established in the 1920s as Apple Pie Inn, was first located on the north side of Highway 1, and served pies made from the Posts's famous 16-ounce pippins. The business was later moved across the highway, and by 1943 Hans and Esther Ewoldsen were running River Inn, as they renamed it. That year Esther was appointed postmaster of Big Sur Post Office, and the post office then moved to River Inn. At the time, a total of eight persons received mail there. The building seen here *c. 1945* was constructed by Hans while he and Esther operated the resort. River Inn is today a popular destination, with a fine restaurant, general store, and motel. (Harbick Collection; courtesy California History Room, Monterey Public Library.)

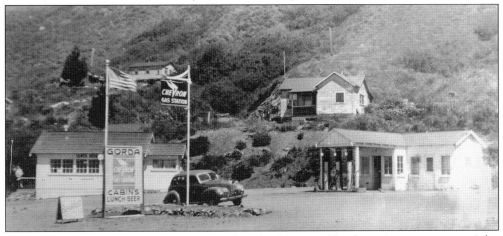

Gorda Station, on the South Coast, was built on land patented by the U.S. government to John C. Evans and partners in 1923. Evans, born in 1870, was the first child of pioneers Thomas and Mary Evans, and operated the business for many years. He had, in 1898, proved up on a homestead claim adjoining those of his brothers Tom and Will in the San Carpóforo Creek watershed. John's wife, the former Lillian Dennis, was the aunt of the late Pat Hettich, whose daughters married into the Post and Pfeiffer families. The village of Gorda remains as one of the few roadside businesses on the South Coast. (Courtesy Sylvia Trotter Anderson.)

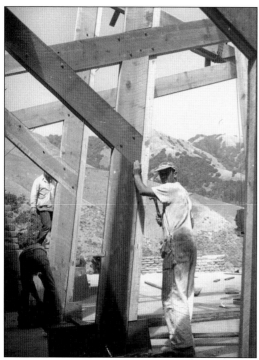

Bill Fassett (1911–1992), who opened Nepenthe with his wife, Lolly, in 1949, is seen here c. 1948 helping to build the world-acclaimed restaurant; the land was purchased from actor Orson Welles in 1947. Designed by Rowan Maiden, a student of Frank Lloyd Wright, Nepenthe (from the Greek word for a drug said to alleviate sorrow) is one of Big Sur's most-visited establishments. Aside from the outstanding meals served in the restaurant, the complex of buildings also includes a bookstore and an intriguing gift shop. The business is still owned by the Fassett family, with management now in the third generation. (Courtesy Erin Gafill.)

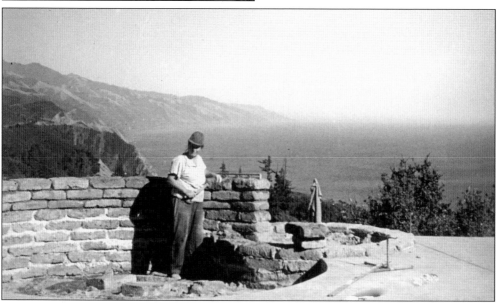

Lolly Fassett lays adobe bricks at the outdoor fire pit on the Nepenthe terrace with a sweeping view of Big Sur's South Coast as a backdrop in this c. 1948 photo. Born June 16, 1911, Lolly was the granddaughter of San Francisco attorney Frank H. Powers, the co-founder of the town of Carmel-by-the-Sea in 1903. Lolly's uncle, Gallatin Powers, was the restaurateur who established Gallatin's Restaurant at the historic Stokes Adobe in downtown Monterey, and the short-lived Crocodile's Tail at the north end of Bixby Bridge. Lolly Fassett, who died on January 19, 1986, was a kind-hearted woman, generous to a fault, and the guiding spirit of the Nepenthe legend. (Courtesy Erin Gafill.)

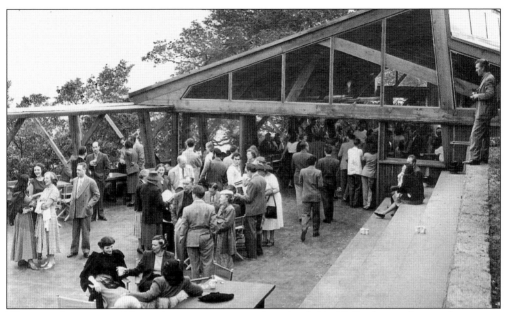

This was the scene at Nepenthe on its opening day, April 24, 1949. A crowd jams the terrace as famed photographer Cole Weston (far right) sets up his camera equipment at the top of the cement bleacher seats. Nepenthe soon became the place to see and be seen in Big Sur. It was the favorite hangout of Henry Miller and his cronies, with sculptor Harry Dick Ross as the convivial bartender. Nepenthe's costume parties became famous, and are still held each Halloween. The place represents a quantum leap from its earlier incarnation as the Trails Club, a log cabin retreat for the Principia College intellectuals who sold the property to Orson Welles and his wife, Rita Hayworth, in 1944. (Courtesy Erin Gafill.)

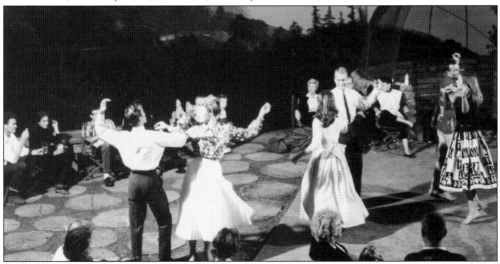

Folk dancing on the Nepenthe terrace was a cherished tradition, as seen here c. 1963. Nepenthe's reputation grew after the release of the Elizabeth Taylor-Richard Burton movie *The Sandpiper*, filmed in Big Sur in 1963. The production featured a folk-dancing scene on the terrace, along with sequences shot at the Doud Ranch on the North Coast, Pfeiffer Beach, and Slate's Hot Springs. The movie was directed by Vincente Minelli, produced by Big Sur resident Martin Ransohoff, and also starred Eva Marie Saint and Charles Bronson. (Courtesy Erin Gafill.)

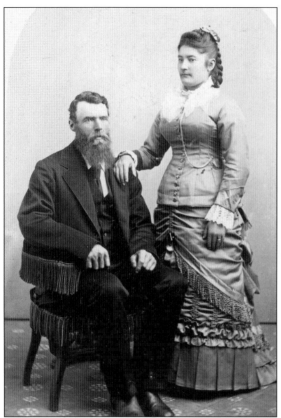

The first tourist-oriented business on the Big Sur Coast was probably Slate's Hot Springs, which was being cited as a visitor destination as early as the 1880s. The mineral springs were operated by Thomas Benton Slate and his wife, Bersabé, seen here on their wedding day, August 26, 1880. Slate, who suffered from severe arthritis, had first come to the springs about 1870. He had to be carried part of the way; after a two-month sojourn, Slate was able to walk out. Another arthritis attack in 1872 brought him back, although a squatter, one B.S. Andrews, was by then in residence. Slate bought him out and later homesteaded the property. His wife, Bersabé, was the daughter of Esequiél Soberanes Sr. (Courtesy Margaret Waters Harrell.)

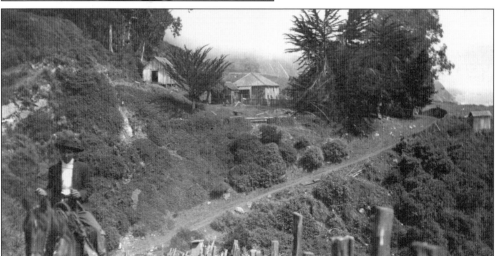

This photo of the Hot Springs Ranch, showing Thomas Slate's former home, was taken by John A. Little c. 1910. The rider is leaving the ranch, northbound on the County Trail, having just crossed Hot Springs Creek. Artist Maynard Dixon, who visited in 1897, later referred to "The Springs" as "the great-natural-hot-sulphur-springs-health-resort where nobody comes who does not have to." A technical report stated that the complex of ten thermal springs had a combined flow of some 50 gallons per minute, with a range in temperature from 100°F to 121°F. (Courtesy Jeannine Little Karnes.)

A gentleman washes his clothes at Slate's Hot Springs in this *c*. 1900 photograph. The steep and narrow pathway leading to the tubs can be made out, just above his head. J. Smeaton Chase spent the night at "Slate's" in the summer of 1911, referring to it by that older name, also calling the place Little's Springs, for former owner John A. Little, whose family bought the land from Slate in 1894. Chase described the situation of the baths in his classic *California Coast Trails*, published in 1913. "It was an enjoyable experience," Chase wrote, "to bathe thus, as it were, in mid-air, with gulls screaming all around and breakers roaring fifty feet below." (Courtesy Pat Hathaway; 95-42-24).

This encompassing view of the Slate's Hot Springs property was photographed by Lou G. Hare in the early 1900s. Perched on a wave-cut terrace, the fields were farmed and also used for livestock grazing. The structure seen at the far left is likely the windlass used to haul bathtubs up from the beach, where they had been landed by a fishing boat. In those days, horses and mules were usually used for bringing materials down the coast, and heavy cast-iron tubs were beyond the capacity of such pack animals. In 1911 the hot springs property was purchased by Salinas physician Henry C. Murphy. (Courtesy John and Helenka Frost family collection.)

Hot Springs Lodge, completed in 1939, is seen in this Harry Hartmann photo, c. 1950. When he bought the property, Dr. Henry Murphy intended to develop the springs as a health spa, but a lack of easy access created a delay. Even with a new highway built through the property by the 1930s, the resort languished during World War II. However, it was certainly frequented by locals; Henry Miller spent his first day in Big Sur here in February 1944, taking "a rejuvenating bath outdoors at the hot sulphur springs." Seen at the left of this photo is the old Hot Springs Creek bridge, a wooden structure now replaced by concrete and steel. (Harbick Collection; courtesy California History Room, Monterey Public Library.)

The baths at Slate's Hot Springs underwent a renovation after World War II. This 1953 photo, taken by Dolph Tewes, shows one of the newer tubs, and the cement reservoir from which they were filled. The baths were nominally segregated into a men's side and a women's side, hearkening back to the old days when a flag was flown, visible from the top of the cliff, signifying that the baths were occupied. Destroyed by landslide later in the 1950s, and again after a fierce winter storm in February of 1998, the baths have since been rebuilt, based on the elegant design of Partington Ridge architect Mickey Muennig. (Harbick Collection; courtesy California History Room, Monterey Public Library.)

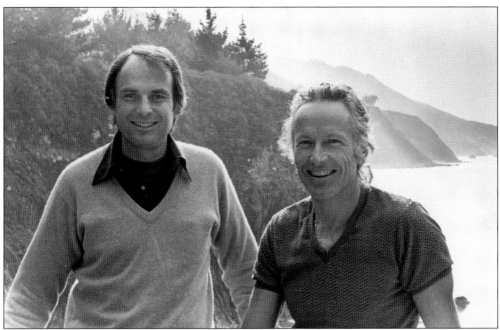

Shown here are Esalen Institute founders Michael Murphy (left) and Richard Price in a June 1985 photo by Kathleen T. Carr. Murphy, the grandson of Dr. Henry Murphy, attended Stanford University with Price, both graduating in 1952 with degrees in psychology. In 1961 they took over the operation of the hot springs, still owned by Murphy's family, and in January 1962 invited Zen student Alan Watts to present a seminar there, the beginning of the Esalen phenomenon. In September 1962 Murphy and Price offered weekend seminars entitled "The Human Potentiality," from a phrase coined by Aldous Huxley, who had visited earlier that year. Price and Murphy renamed the place Esalen Institute, to honor the original residents of that portion of the Big Sur Coast. (Courtesy Esalen Institute.)

Frederick S. "Fritz" Perls, the chief proponent of Gestalt therapy, became a resident at Esalen in 1964. Born in Berlin in 1893, Perls, who held an M.D. from Kaiser Wilhelm University, fled Germany in 1933 when Hitler came to power. Trained as a Freudian psychoanalyst, Perls established a successful practice in South Africa, but left for the United States in 1946 prior the establishment of apartheid; he later claimed that he could sense the approach of repression. Perls co-authored the seminal *Gestalt Therapy* in 1951; by the time of his death, in 1970, the name of Fritz Perls had become nearly synonymous with that of Esalen. (Photo from the mid-1960s by Paul Herbert; courtesy Esalen Institute.)

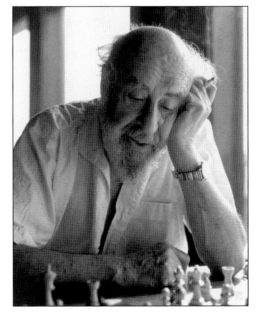

Gregory Bateson (1904–1980), seen here in a late 1970s portrait by Horst Mayer, co-led his first seminar at Esalen, entitled "Individual and Cultural Definitions of Rationality," in the fall of 1962. Bateson studied the cultures of Bali and New Guinea with his then-wife Margaret Mead, and had been Richard Price's anthropology professor at Stanford. Bateson, who established a home on the South Coast at Gorda Mountain, was greatly interested in the origins of mental illness, and his "double-bind" theory concerning schizophrenia's causes is widely respected. Bateson's vision was wide-reaching, encompassing cybernetics and the communication of marine animals, as well as anthropology, psychiatry, genetics, and systems theory and ecology. (Mayer Family Collection; courtesy Kathy MacKenzie.)

Buckminster Fuller (1895–1983) lectured at Esalen Institute in 1967. The engineer discovered energetic/synergetic geometry in 1917 and in 1927 designed "Dymaxion House," a prototype for mass-produced, efficient, "trouble-free" living. His work with space-saving polyhedral structures after 1945 culminated in the unveiling of the famous geodesic dome at the U.S. Pavilion during the 1967 Montreal Exhibition. As an Esalen catalogue stated, "Though Bucky's primary authority arose from his grasp of modern technology, his life-affirming vision of human possibility made him one of our most beloved mentors." (Photograph by Paul Herbert; courtesy Esalen Institute.)

Three

FROM HORSE TRAIL TO HIGHWAY

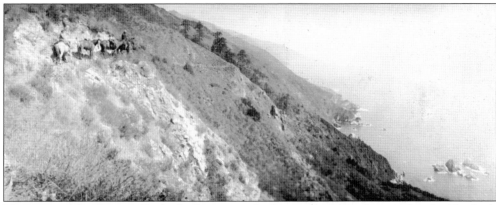

This view of the County Trail, also known as the Lower Coast Trail, was taken by Elizabeth Livermore *c.* 1910. The location is now within Julia Pfeiffer Burns State Park. At the right can be seen the sea stacks known as McWay Rocks. This segment of the trail was built in the 1880s to avoid the unnecessary elevation changes of an older route. South of Slate's Hot Springs, the trail became increasingly difficult to follow, not being maintained with county funds. By 1913 a proposal had been made to extend the County Road south from its terminus at the Castro Ranch. County Surveyor Lou G. Hare mapped the route, which was never built. Hare's friend, Dr. John Roberts, together with State Senator Elmer Rigdon of Cambria, south of San Simeon, lobbied state officials for years, hoping to see an all-weather road built. Highway construction finally commenced in 1922. One crew worked north from the San Carpóforo Creek area, where San Luis Obispo County's coast road ended, and another worked south from Castro Canyon; the job was completed in 1937. (Courtesy Ewoldsen family.)

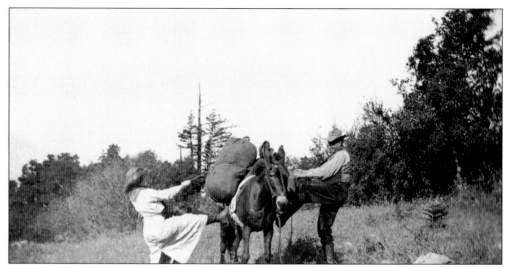

Traveling along the coastal trails was a slow process, requiring sure-footed horses and mules. Here, c. 1915, John A. Little and Elizabeth Livermore enjoy the moment while they pack a mule with a lopsided load. Although the trail north of Slate's Hot Springs was well graded, access was limited during winter months by landslides and streams swollen by rain. Settlers could resort to the higher Coast Ridge Trail (also called the Upper Coast Trail), but winter snows might also block the way. South of Partington Canyon, east-trending paths offered access to the Salinas Valley. Such routes were used by settlers to obtain supplies and to drive livestock for shipment by railroad. (Courtesy Jeannine Little Karnes.)

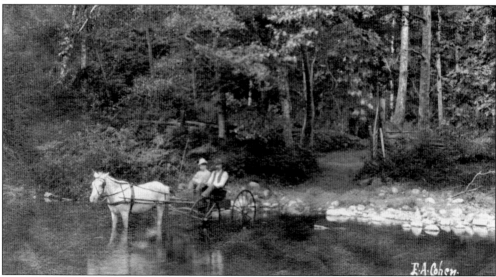

This ford over the Big Sur River, photographed c. 1907 by Edgar Cohen, was known as the Indian Crossing. After the County Road was extended south to the Post Ranch in the 1880s, travelers needed to make 13 similar fords of the Big Sur River. This one was located near the former home of Manuel and Francisca Innocente, a Native-American couple who came from Southern California. When the Pfeiffers arrived on the coast in 1869, the only residents of the Big Sur Valley besides the employees at Rancho El Sur near the river mouth were the Innocente family. Their home site is now within Pfeiffer Big Sur State Park. Manuel Peak, dividing the Big Sur River from the Little Sur, was named for Innocente. (Courtesy Ewoldsen family.)

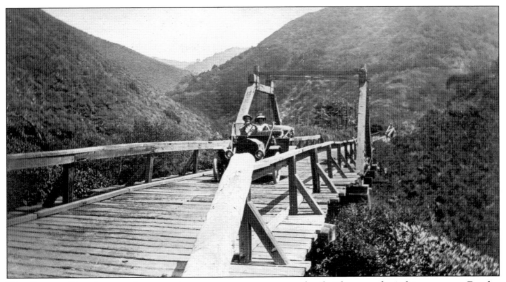

The County Road crossed streams in steep canyons on wooden bridges, such as this one over Rocky Creek, *c.* 1912. This rustic affair was later replaced by a steel bridge, prior to the construction of the graceful cement-arch bridge during the building of Highway 1. Redwood timbers, available in nearly every coastal canyon, were a superior material for bridge construction. If the bridge happened to wash out during a winter storm, new timbers could be readily obtained. In the background of this photo rises Division Knoll, separating Rocky from Bixby Creek. (Courtesy Franklin Peace.)

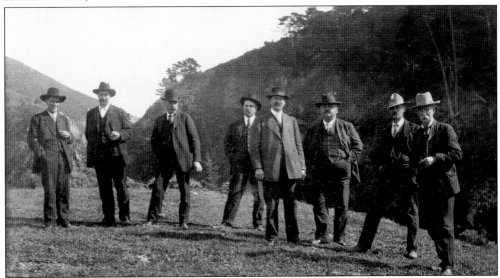

In 1908 the Monterey County Board of Supervisors, photographed by Lou G. Hare, met at Malpaso Canyon to discuss the construction of a bridge over the creek. The canyon had been an obstacle to travel since the days of the Spanish, who gave it the place name, literally translated as "bad crossing," due to the steepn terrain. From left to right are landowner W.J. Towle, Sam Trotter, Al Cushing, and the five supervisors. Although otherwise unnamed, the board members at that time were J.L. Mann, H.E. Abbott, T.J. Field, Paul Talbott, and William P. Casey. Cushing's father Volney owned Palo Colorado in the 1870s; Trotter may have been considering placing a bid on the job. (Courtesy John and Helenka Frost family collection.)

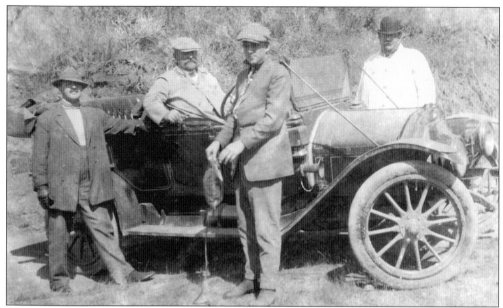

Seen here are a group of intrepid motorists on a foray to Big Sur on the County Road, photographed by Dorothy Hare *c.* 1914. From left to right are County Supervisor Dr. John L.D. Roberts (1861–1949), County Surveyor Lou G. Hare (1867–1921), Lou's son Evatt, and Andrew Molera. The travelers had stopped to fill the radiator of Hare's Overland touring car. Roberts, founder of the city of Seaside, near Monterey, made "house calls" to his Big Sur patients, besides agitating for highway construction. Molera's cousin, Alfred Cooper, was the first known auto fatality in Big Sur. Cooper died when his chauffeur-driven car overturned on the County Road in 1913. (Courtesy John and Helenka Frost family collection.)

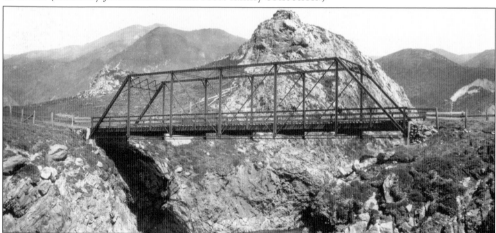

The steel bridge over Garrapata Creek, seen here in a 1920s photo by Lewis Josselyn, replaced the low wooden bridge that formerly crossed the stream. It was followed by the concrete bridge, built a few hundred feet inland, that carries highway traffic to this day; as might have been expected, steel bridges do not fare well in the salt-laden air near the ocean. Garrapata Creek was named in Spanish times for the abundance of wood ticks, or *garrapatas*, which, it has been said, "explored the early explorers." North of the creek mouth, seen here, extends Garrapata Beach, a destination for visitors for over a century and now part of Garrapata State Park. (Courtesy Pat Hathaway; 71-01-BS-50).

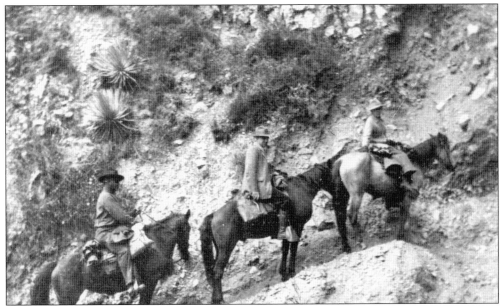

"Doc" Roberts, dismayed by the lack of medical attention in Big Sur, spent years pleading for highway funding from the State of California, but it finally took World War I to convince legislators that a better road was needed. By virtue of the Military Highways Act of 1916, state money was allocated to build a paved highway between Carmel and San Simeon. Surveying began in 1919, requiring crews to be packed in over the various trails. Seen here is J.W. (Joe) Post Sr., *c.* 1919, escorting members of a survey crew, who seem to have reached the end of the line. Post's son, J.W. (Bill) Post Jr., also worked with these crews. (Big Sur Historical Society.)

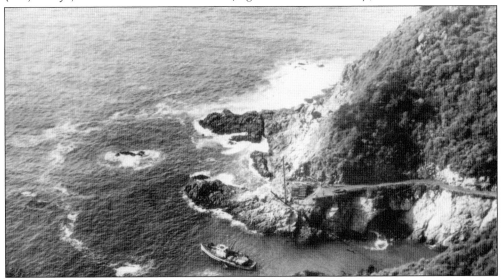

The remote Big Sur country proved difficult to penetrate, and road builders employed unusual methods to get the job done. The contractor on the north end of the project ingeniously brought in equipment and supplies by boat, using the old Seaview Landing at Partington Cove. This fact was documented in the photo seen here, taken on May 12, 1924 by highway engineer James Knapp. Once landed, the contractor used steam-powered donkey engines to winch the material up to the level of the new road. (Big Sur Historical Society.)

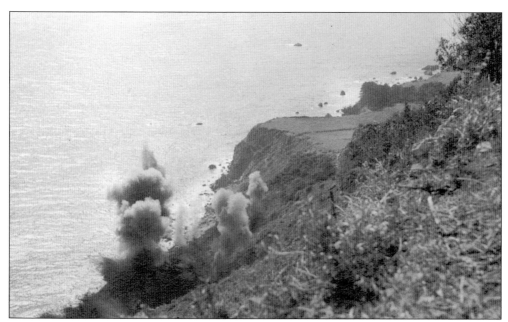

The steep terrain was little suited for a two-lane highway, and road builders used tons of dynamite to soften up the hillsides. Here, blasting at Lime Creek was captured on film by Hans Ewoldsen in the late 1920s. The marine terrace at Slate's Hot Springs, now Esalen Institute, can be seen in the background. One unexpected benefit of the extensive blasting was the universal availability of empty dynamite boxes; locals, for whom milled lumber was something special, used these boxes for roofing, flooring, shelving, and sign-boards, among many other applications. Some households still feature old dynamite box construction to this very day. (Courtesy Ewoldsen family.)

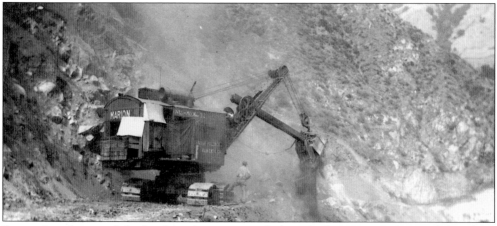

Steam shovels amazed the local residents, many of whom had spent a good part of their lives behind the hand-operated variety. Here, an operator side-casts the overburden, thus building up the outer edge of the roadway. Soil loosened in this way might cascade far downslope, and often entered the marine environment. It is said that after the road was built, abalones became scarce, having been buried under road-generated dirt and rock. Old timers also tell of finding pearls in the abalones that could still be hunted; the large mollusks coated tiny bits of irritating rock with mother-of-pearl, giving a bonus to those who took the time to prepare this delicious cousin of the snail. (Courtesy Pat Hathaway; 20-41-01).

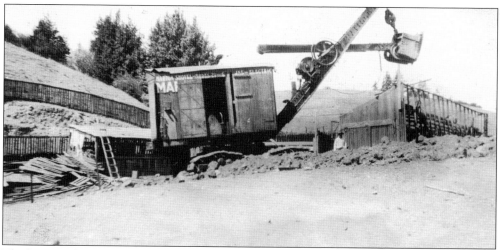

The barn at the Post Ranch, yet another obstacle in the way of the progress of Highway 1, is dismantled in this photograph, c. 1923. The Posts then built another barn, located at the site of the present-day Cielo Restaurant at the Ventana Inn. Despite the loss of property, locals benefited from improved access to and from their ranches. Livestock and forest products could be brought to market far more easily, and people living on the coast could get into town quickly if they needed medical help—a fact certainly not lost on old-timers, some of whom could remember the "good old days," when summoning the nearest doctor involved a two-day ride. (Courtesy J.W. Post III.)

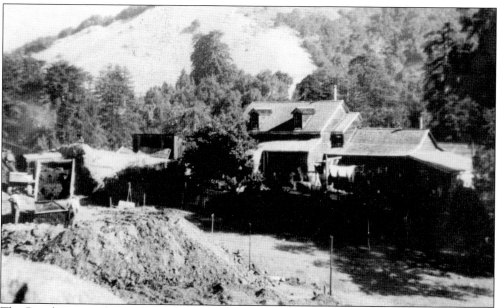

The Post homestead, seen here during highway construction, seems to be lost behind piles of dirt. Some ranchers were seriously inconvenienced by road-building activity; George Harlan had his South Coast home cut off from his barn, the highway having been pushed through his front yard. He was eventually able to convince the California Division of Highways to install a tunnel beneath the highway, allowing his cattle to graze in upland pastures as well as those between the highway and the ocean. (Big Sur Historical Society.)

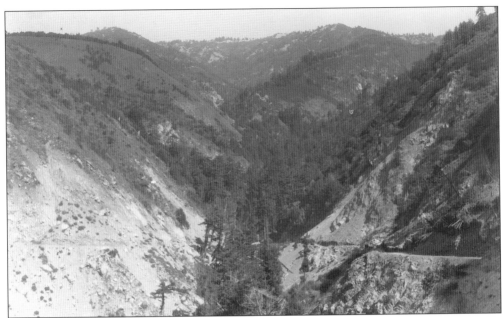

Building the highway was not a pretty sight, as seen in this image at Partington Canyon, photographed by Lewis Josselyn c. 1931. Huge charges of dynamite were set off on the south side of the canyon; engineers placed the explosives to generate rubble that would act as a base for building up the roadbed. Many were aghast at the destruction. As Jaime de Angulo, attracted to Big Sur by its great natural beauty, opined in a 1923 letter (written after a visit with Carl Jung in Switzerland), "But *my* coast is gone, you see . . . My first reaction of course was one of intense sorrow and horror. My Coast had been defiled and raped." (Big Sur Historical Society photo; quote courtesy Gui Mayo.)

Looking like Hoover Dam, the destruction of Partington Canyon was complete. All that remained was the widening and lowering of the roadbed to its present level. This wall of dirt amounted to 120,000 cubic yards of overburden. Rock at the base of the fill was fallaciously expected to act as a "French drain," through which the waters of Partington Creek would readily pass; later, highway workers needed to install a metal culvert. The migration of steelhead salmon beyond the highway was thus forever blocked. Many still feel that bridges would have provided more appropriate means for constructing the highway through this and other coastal canyons. (Photo by Lewis Josselyn, c. 1931; courtesy Pat Hathaway; 71-01-BS-271.)

Shown here is the old steel bridge over the Big Sur River as it appeared in 1938. Although the steel arch has been removed, the bridge still sees service for visitors to Pfeiffer Big Sur State Park. The present highway bridge crossing the river, located a short distance downstream, was completed in 1940. In the 1800s the old Coast Trail made a single crossing of the Big Sur River, continuing south along the crest of Pfeiffer Ridge. The "new" 1880s wagon road, an engineering marvel to be sure, required many often-precarious fords of the river. With the construction of the highway, stream crossings were reduced to just one, as in the past. (Frank Trotter Collection, Big Sur Historical Society.)

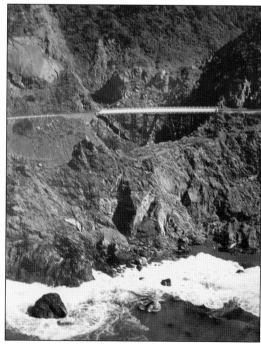

Villa Creek on the South Coast was crossed by this elegant bridge supported by wood trestles in this 1940s photograph. As newer and heavier vehicles began using Highway 1, the wooden bridges were replaced by modern steel and concrete installations. Although all major bridges on the highway have been seismically retrofitted to withstand earthquakes, some skeptics wonder if the older bridges might have been resistant as well, since the trestles bestowed a degree of flexibility to the overall structure. As the wooden bridges were dismantled, local builders reaped a bounty from the surplus trestles; many a home along the coast has been constructed from the massive timbers. (Courtesy Stan Harlan.)

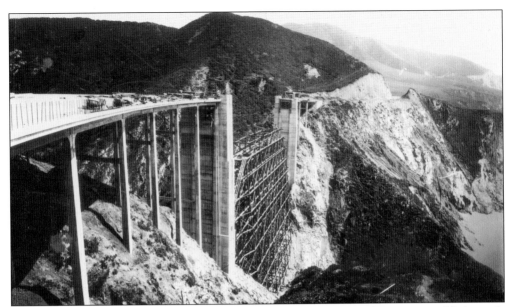

The building of Bixby Bridge was symbolic of the huge effort required to construct Highway 1. Bixby Canyon itself was one of the steepest along the coast, and the old County Road turned inland here, making a ten-mile detour around some of Big Sur's most impassable terrain. At 714 feet in length, Bixby Bridge, shown here in this May 23, 1932 photo by Lewis Josselyn, has been described as one of the world's largest single-span concrete arches, with Bixby Creek flowing some 260 feet below. Despite this, the structure is fragile; after a convoy of heavy equipment was halted on the bridge for several hours in 1977, highway crews discovered numerous cracks on the supports, requiring lengthy repairs. Seismic retrofitting in the late 1990s took more than a year to finish. (Courtesy Pat Hathaway; 71-01-BB-7.)

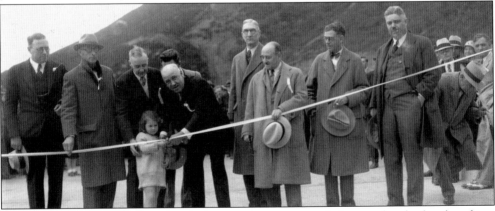

When Bixby Bridge was completed, dignitaries came out of the woodwork, for the photo opportunity if nothing else. Here, young Audrey Mawdsley, daughter of Carmel residents Mr. and Mrs. Peter Mawdsley, cuts the ribbon at a bridge-opening ceremony photographed on November 27, 1932 by Lewis Josselyn. Regrettably, the names of the host of worthy officials assisting Miss Mawdsley were not recorded. Thirty-four years later, the First Lady of the United States, Mrs. Lyndon Baines (Lady Bird) Johnson, stood a few feet from this spot when she dedicated Highway 1 as California's first Scenic Highway. The event, held on September 21, 1966, marked the recognition of Highway 1 as a resource of national significance, a roadway of which all Americans can be proud. (Courtesy Pat Hathaway; 71-01-BS-077.)

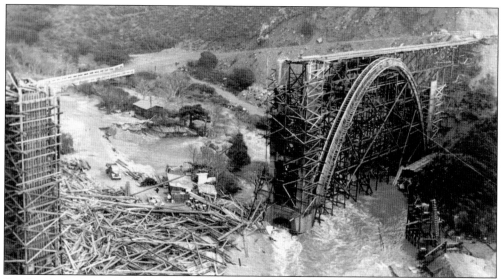

Big Creek Bridge on the South Coast is another magnificent concrete structure, although its builders faced setbacks. The falsework erected to enable pouring of the bridge's concrete required uncounted board feet of lumber, and during a single night of freakish winds the north half of the framework blew down. The destruction may have been abetted by high water in Big Creek, seen here copiously flowing into the ocean. The falsework was reinstalled, but the delay kept the bridge from being completed on schedule. It finally opened to traffic in September 1938, a year after the rest of the highway had been finished. (Courtesy Pat Hathaway; 94-83-01.)

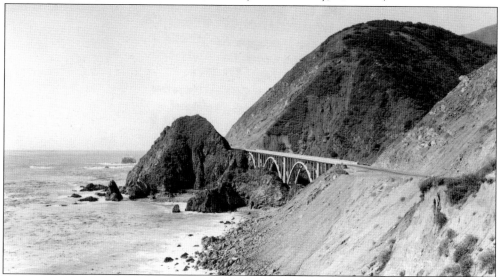

The newly completed Big Creek Bridge was, and is, one of the most visually appealing on the coast. The structure consists of two complete arches, with two half-arches that tie the ends of the bridge to the walls of the canyon. The concrete from which the bridge is constructed was made from sand obtained at Limekiln Beach a few miles to the south. This sand, derived from the greenstone rocks of the Franciscan geological formation, causes the bridge to blend in with the local landscape of Big Creek, also located on Franciscan substrate. The site today is part of Landels-Hill Big Creek Reserve, administered by the University of California. (1938 photo by Lewis Josselyn; courtesy Pat Hathaway; 71-01-BS-248.)

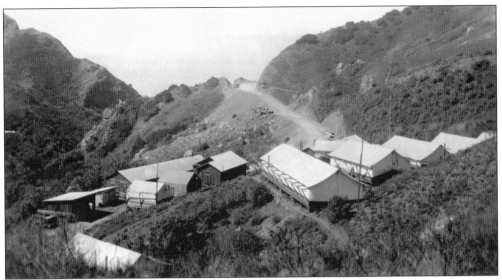

By the 1930s highway construction employed convict labor, and the prisoners generally enjoyed the chance to get some fresh air and exercise. Cons were housed in camps such as this one, located at Salmon Creek. As work progressed, the camps were moved. The last such camp was located at Anderson Canyon, a few miles north of Slate's Hot Springs. After the highway was completed and the convicts returned to prison, the abandoned Anderson camp was occupied by a succession of bohemians, including painter Emil White, musician Harry Partsch, and writer Henry Miller. When the Salmon Creek convict camp was moved, the U.S. Forest Service requisitioned several of the structures, which remain today as the Salmon Creek Guard Station. (Courtesy James R. Krenkel.)

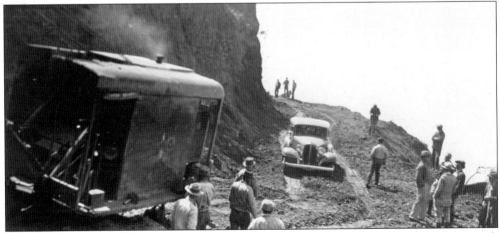

Seen here is the first car to pass from the south end of highway construction to the north end. The date was September 18, 1934, and at the wheel was Lester H. Gibson, the engineer who first began work on the highway during the survey phase. Don Harlan, who later served as highway maintenance foreman on the South Coast, recalled the moment when the last chunk of dirt separating the south crew from the north crew was removed. An engineer named Henderson was operating the steam shovel, "flinging dirt like mad." When he punched through, Don and his family expected to be able to drive north; however, as soon as the breakthrough was accomplished, Henderson turned around and piled earth back in the gap. (Big Sur Historical Society.)

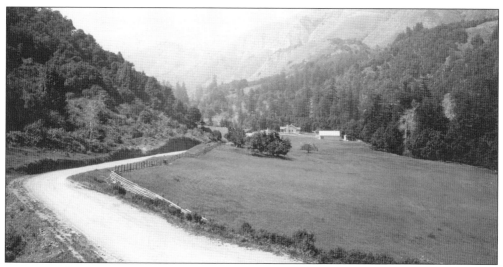

Because of the complex geology of the Big Sur Coast, Highway 1 must be constantly attended to. The route currently falls under the responsibility of three maintenance crews, two of which are resident staff. One maintenance station is at Willow Springs near the South Coast town of Gorda; the other crew lives at, and works from, a station in the Big Sur Valley. The first Big Sur maintenance yard, photographed here by Lewis Josselyn *c.* 1934, was built on John Pfeiffer's ranch. Later, a U.S. Forest Service guard station was added, and between 1989 and 1991 the entire complex was torn down and rebuilt at the same site. Today the location is referred to as the Big Sur Multi-Agency Facility, or simply the Big Sur Station. (Courtesy Pat Hathaway; 71-01-BS-140.)

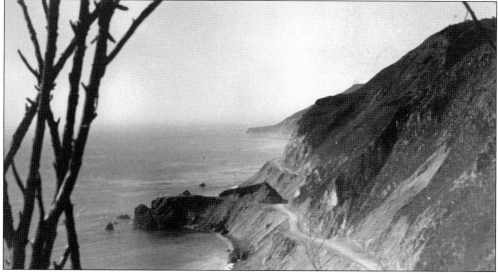

A view of the unpaved highway looking north to Limekiln Creek in the 1930s shows Lopez Point in the distance. In the foreground is Limekiln Point, where Rockland Landing was built in the 1880s. After highway construction was completed, festivities included an opening ceremony, hosted by Gov. Frank M. Merriam on June 27, 1937. At the time, the official designation for the highway was State Route 56. A local newspaper reported that Merriam "clipped ribbons, dedicated monuments, set off powder blasts, released pigeons, and posed for photographs all day long." Although the actual work took some 19 years, none should forget the efforts of Dr. John L.D. Roberts, who began advocating this scenic road in the 1890s. (Courtesy James R. Krenkel.)

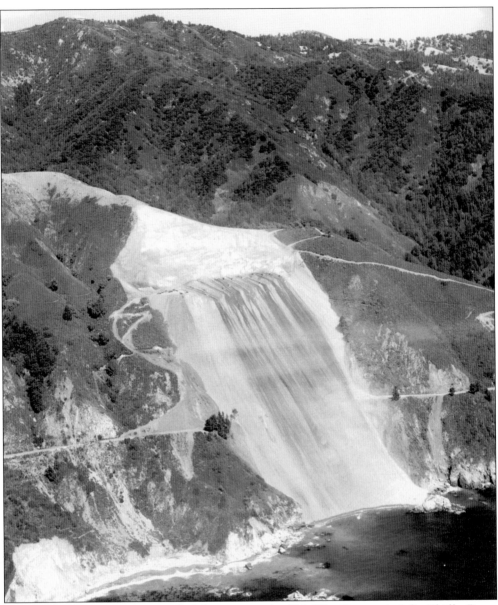

On April 20, 1983, a massive earth failure just north of McWay Canyon in Julia Pfeiffer Burns State Park closed the highway for nearly a year. Earlier slides, one of which took the life of a bulldozer operator, had blocked Highway 1 to the north during that 1982–1983 season. Caltrans spent nearly $8 million to fix the "Julia Pfeiffer Burns Slide," which required the excavation of some 3 million cubic yards of mountainside. Most overburden was pushed into the ocean, as seen here in this Caltrans photo, causing unprecedented damage to undersea habitats. The impact on the Big Sur community, cut in two by the landslide, was also unprecedented: many businesses closed, some residents moved away, and those that remained experienced a changed life—something reminiscent of the old days before the highway was built. On March 21, 1984 the road was reopened to locals, and on April 11, after paving 1000 feet of damaged or rebuilt highway, an official ceremony was held, and Highway 1 was returned to visitors and locals alike. (Big Sur Historical Society.)

Four

ELEMENTS OF
THE COMMUNITY

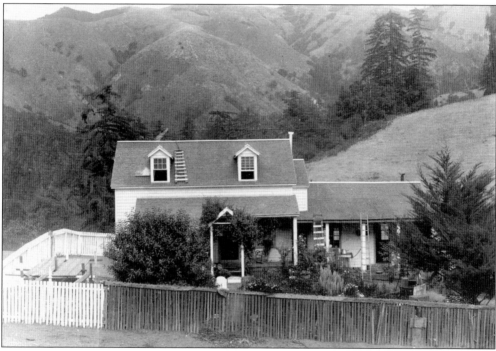

The Post homestead was the site of the first post office in the Big Sur Valley, established on December 9, 1889, as Posts Post Office. William Brainard Post, who had earlier worked hard to get the County Road built to his ranch and beyond, was the first postmaster, an office he held until 1905. It is said that some mail was misdirected due to confusion with the military post in Monterey. When this photo was taken *c.* 1900, mail was delivered by horse-drawn stage on Mondays, Wednesdays, and Fridays. An all-day trip was required from Monterey, and the driver would spend the night down the coast before returning the following day. The old Post house today marks the entrance to Ventana Inn. Despite the area's remote situation, government services such as post offices, roads, libraries, and schools held the community together a century ago. These days, Big Sur derives further benefits from citizen organizations, including its health center, the grange, a chamber of commerce, a property owners' organization, and several fund-raising groups. (Courtesy Franklin Peace.)

Florence Pfeiffer took over as postmaster in 1905, and Posts Post Office moved two miles north to the Pfeiffer home, in today's Pfeiffer Big Sur State Park. When their place burned in 1910, the family relocated to an older cabin closer to the river, where the Big Sur Lodge is now situated, and the post office moved with them, undergoing a name change to Arbolado Post Office, seen here in a 1912 view of the mail stage. In 1915 the final designation of Big Sur Post Office was applied at this same location after locals petitioned the government for a name denoting the site along the Big Sur River. (Courtesy Ewoldsen family.)

Seen here is Sur Post Office, along Bixby Creek, c. 1908. The location of post offices reflected the current needs of the community, and when Sur Post Office was established in 1889, Bixby Canyon bustled with activity centered around Charles Bixby's farm and sawmill. Earlier, Bixby Canyon had been the site of the first post office on the Big Sur Coast. The short-lived Point Sur Post Office, located at Bixby's Mill, was authorized on January 24, 1883, and closed on October 15 of that year. Sur Post Office, discontinued in 1913, was visited by Smeaton Chase in the summer of 1911, after floods had wiped out the Monterey Lime Company. As Chase wrote, the tiny structure "gave no token of its use, for mail-boxes and sign-board had gone out to sea together during the winter rains." (Courtesy Ewoldsen family.)

The horse-drawn stage was eventually replaced by a motor stage, seen here about 1920, shortly after the change occurred, when J.W. (Bill) Post Jr. was the driver. Travel could still be difficult, and J.W. Jr., known as the "Old Master," told of the problems he would encounter on descending Serra Grade to the Little Sur along the County Road (today's Old Coast Road). The brakes were insufficient to hold the stage back, so he would routinely cut a bundle of roadside brush and tie it to the rear bumper. But the Old Master eventually removed so much shrubbery that it became a real chore to climb the bank for a new set of "brakes." (Courtesy J.W. Post III.)

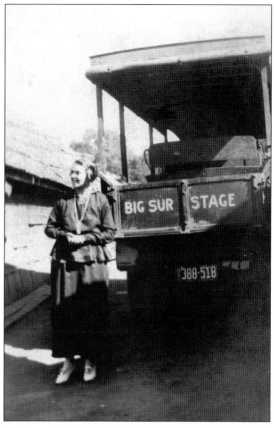

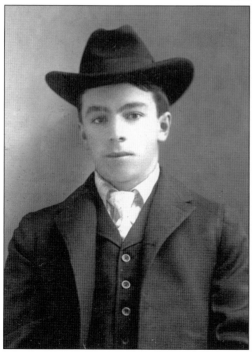

John Corbett Grimes (1885–1950) also drove the stage for many years. Corbett came to the United States from England in 1903 to visit his uncle Edward Grimes; he is pictured here shortly after his arrival. On May 26, 1919 Corbett married Electa Dani (1897–1974), the daughter of Alvin and Mary Ellen Pfeiffer Dani, and for many years they lived at the Swetnam house at Palo Colorado Canyon. Corbett, besides serving as mail carrier, was a Monterey County roadmaster for some 30 years, a job that entailed the maintenance of county routes, including Palo Colorado Canyon Road near his home. Grimes is also remembered for having one of the rare telephones on the coast; general phone service was finally extended to most of Big Sur in 1957. (Courtesy Franklin Peace.)

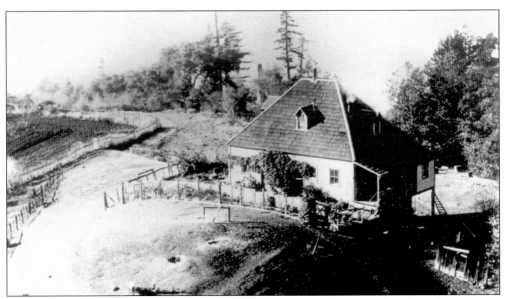

The Lucia Post Office opened on March 8, 1900 at the Elizabeth and Gabriel Dani home, shown here. The first postmaster was Violet Lucia Dani (1878–1947), Gabriel and Elizabeth's eighth child. Mail was brought by horseback from Jolon to Gorda Post Office, located at Pacific Valley. Getting that far took a whole day; next morning, the mail carrier made the ride to Lucia Post Office and returned to spend a second night at Pacific Valley before returning to Jolon. At that time Lucia Post Office served some 65 local residents. The Dani house burned shortly after the property was acquired by the Benedictine Order of Camaldolese monks in 1958. The Dani's Lucia Ranch is now known as the Immaculate Heart Hermitage. (Courtesy Stan Harlan.)

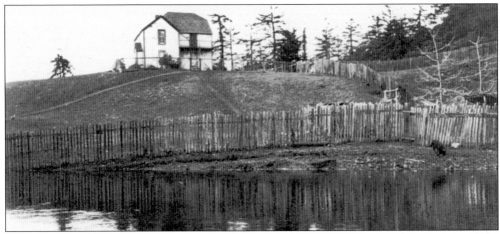

Beginning in 1906, Ada Harlan, wife of Wilber Harlan, served as the second postmaster of the Lucia Post Office, located at their home, seen here. When J. Smeaton Chase visited in 1911, he found that letters he left there on Monday, "after lying here until Saturday, would be taken to Gorda, where they would wait until the following Saturday before starting to Jolon . . . " Lulu May Harlan succeeded her mother, serving until the post office was discontinued in 1932, with South Coast locals getting their mail through the San Simeon Post Office. Lucia Post Office reopened in 1936 at the newly built Lucia Lodge, but closed again in 1938, with mail delivered via the Big Sur Post Office over the new highway. The Harlan home, a landmark for miles around, burned December 12, 1926. (Courtesy Stan Harlan.)

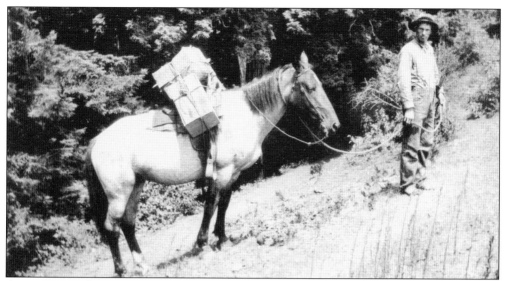

George A. Harlan, with his horse Trixie, carried the mail from Jolon to Lucia Post Office, making the operation of this post office a "family affair." George served from 1920 to 1932, during which time this photo was taken. In his own words, "[t]here was supposed to be delivery once a week and the ride was theoretically one day out and one day back, but this depended on the number of pickups and deliveries. Ordinarily I would use one pack mule, but if I had a big load of parcel post I might need as many as seven animals. I remember packing 1,400 pounds one week." One of Harlan's favorite parts of this trip was cresting the Santa Lucias, with a view of the Salinas Valley and intervening ranges culminating in the snowy peaks of the Sierra Nevada. (Courtesy Stan Harlan.)

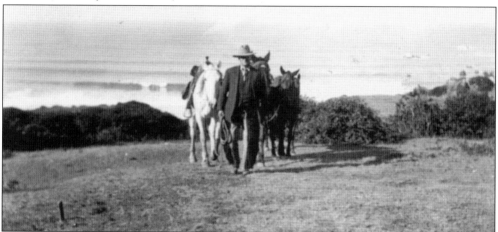

William Bane (1876–1943) was an earlier South Coast mail carrier, seen here at Pacific Valley in November 1923. Bane and his wife, Rebecca, ranched on the east side of the Coast Ridge, in today's Fort Hunter Liggett. The Bane (a.k.a. Mail) Trail followed westerly from their place to the summit of the Coast Ridge, then downslope to Pacific Valley and the Gorda Post Office. Bane's father, Joseph W. Bane, had previously served as the postmaster at Mansfield Post Office, named for Curnell Harry Mansfield, located at the town of Manchester from 1889 to 1897. In his later years, Will Bane served as a guide in the Santa Lucias; this photo was taken when he escorted Monterey County librarian Anne Hadden on a trek to the Pacific Valley School. (Courtesy Monterey County Free Libraries, Salinas, California.)

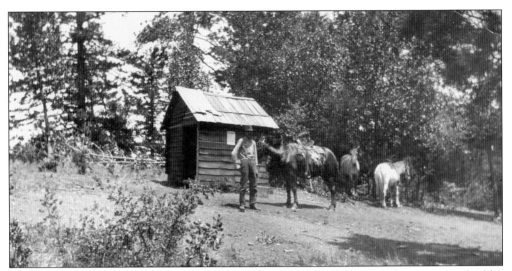

This one-room cabin, *c.* 1900, once situated above Saloon Flat at the headwaters of Alder Creek, functioned as a mail drop for Los Burros settlers. During infrequent visits to established post offices, ranchers and miners would often collect mail addressed to other local residents as well as their own, leaving their neighbors' items here as a favor. Thus, even when the nearby Manchester Post Office was discontinued, inhabitants of Los Burros would still receive mail here, although the location had no official status. This cabin replaced and improved upon the local "mail tree," which served the same purpose. (Courtesy James R. Krenkel.)

Disaster struck the Big Sur Post Office on November 15, 1972, when mudslides inundated its location at River Village just south of the River Inn. Heavy rains, which loosened tons of dirt and rock after the disastrous Molera Fire earlier that summer, closed River Inn, destroyed the Big Sur Garage, and put the local grocery store out of business. The post office later relocated to a trailer near the U.S. Forest Service Big Sur Guard Station, and moved to its present quarters a couple of miles south in 1986. In this picture, Dana Napijalo retrieves one of the last pieces of mail from the River Village post office. (Courtesy Robert Cross.)

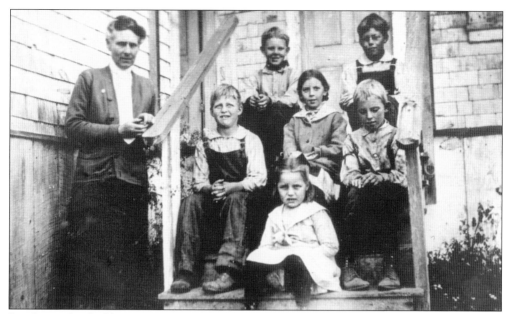

Big Sur's schools, like its post offices, moved with the ebb and flow of its population. While redwood timber and tan bark were being harvested on the North Coast, Eugenia Murray ran a school at her home above Palo Colorado Canyon. Seen here, c. 1918, are Miss Murray (far left), with Lillian Trotter (in front) and, from left to right (middle row) Henry Trotter, Mary Goetz, and Jacob Goetz; (back row) Francis Goetz and Roy Trotter. The Goetzes were early settlers in the Palo Colorado-Rocky Creek area, and were neighbors of the Murrays, who homesteaded about 1875. (Courtesy Lillian Trotter von Protz collection.)

Seen here in a 1951 photo by Arthur McEwen is the abandoned Sur School, also called the Cooper School, attended by J.W. Post III in 1926, when he was in the first grade. Post's fellow students included the children of Point Sur lightstation employees. In the foreground can be seen the gate to the old road leading down to the lightstation; this route followed Dairy Canyon to the coast after branching off the County Road, at the left of the photo. When highway construction had progressed to Point Sur, school was taught at a building constructed at the new highway entrance to the lightstation. In the background of this photo can be seen Pico Blanco, 3,709 feet in altitude. (Big Sur Historical Society photo; courtesy Alan McEwen.)

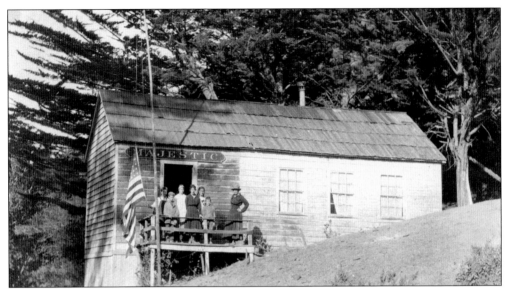

This photo shows the Pfeiffer School (also called Majestic School) at Sycamore Canyon in August 1917, when all the students and their teacher were Pfeiffers. Shown from left to right are John Ivan Pfeiffer, Dewey Pfeiffer, Wilhelmina Pfeiffer, teacher Gladys Pfeiffer, Esther Julia Pfeiffer, Joseph Pfeiffer, and visitor Lottie Zeitfuchs, whose husband, Emil, took the picture. John Ivan and Esther Julia were the children of John Martin and Florence Pfeiffer; Dewey, Wilhelmina, and Joseph were the children of William Nicholas and Alice Dani Pfeiffer. Gladys was the daughter of Charles Pfeiffer, brother of John and William, who had settled in Idaho. (Courtesy Ewoldsen family.)

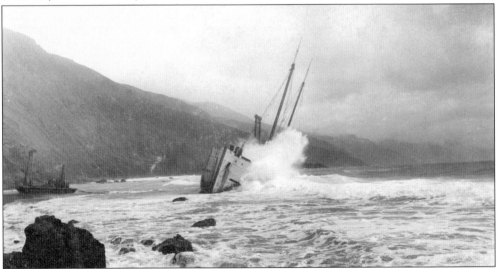

The carved wooden sign above the doorway to the Pfeiffer School bears the single word "Majestic." This was attached to the school after the December 5, 1909 wreck of the 810-ton lumber schooner *Majestic*, seen here. Esther Pfeiffer, who was five years old at the time, recalled that the crew was saved after her aunt, Julia Cecilia Pfeiffer (later married to John Burns), rode her horse through the surf, carrying a lifeline. In return, the grateful captain of the vessel gave the Pfeiffer family the *Majestic* nameplate. The scene of this disaster, just south of Pfeiffer Point, is today called Wreck Beach. (Courtesy Ewoldsen family.)

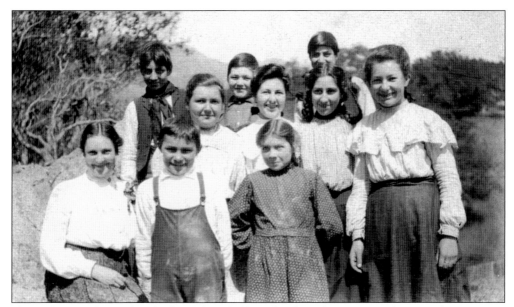

Shown here is the student body of the Pfeiffer School on the Post Ranch *c.* 1905, prior to its next location at Sycamore Canyon. Seen, from left to right, are (front row) teacher Nimpha Narvaez, J.W. Post Jr., Frances Post, and Angie de la Torre; (middle row) Ellen Grimes, Lupie de la Torre, and Rebecca Castro; (back row) Rojelio Castro, Billie de la Torre, and Tony Castro. Nimpha Narvaez later married Jack McWay; the Castro kids lived at nearby Castro Canyon. Frances Post, daughter of Frank and Annie Post, was the mother of Norma Graham of Big Sur. (Courtesy Franklin Peace.)

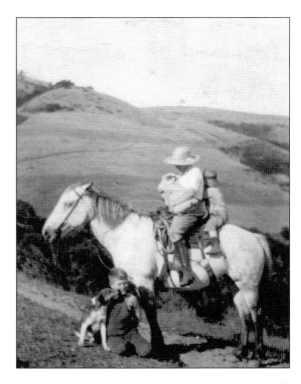

Teacher Esther Harlan, astride Trixie, prepares to ride to the nearby Redwood School in this 1928 photo. Seen left to right are her sons Gene (born 1921), Stan (born 1927), and Don Harlan (born 1925); their dog Tag is at far left. Mary Esther (Essie) Smith was born October 19, 1892, in Campbell, California. She began teaching at Redwood School in 1913, boarding with the Harlans, where she met her future husband, George; they were married on October 29, 1916. Two of Esther's sisters were also teachers, all having graduated from the San José Normal School. Esther Harlan died October 6, 1968. (Courtesy Stan Harlan.)

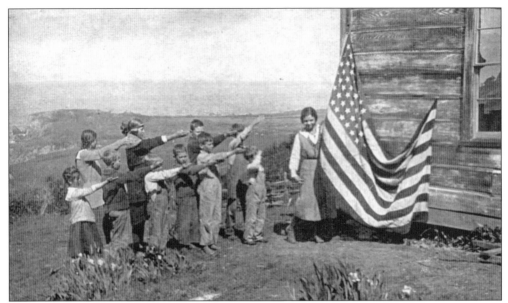

Shown here are the teacher and student body of the Pacific Valley School, on the South Coast. The picture was taken in April 1922 by David Rodney Hadden, brother of Monterey County librarian Anne Hadden. The unidentified children are probably from the Mansfield and Plaskett families. In those days students saluted the flag with their arms outstretched, palm upwards. The modern Pacific Valley School, the only school in the Pacific School District, accepts students from kindergarten to 12th grade; prior to conducting upper grade classes there, students were bused to high school in Cambria, a round trip requiring many hours in the school bus. (Courtesy Monterey County Free Libraries, Salinas, California.)

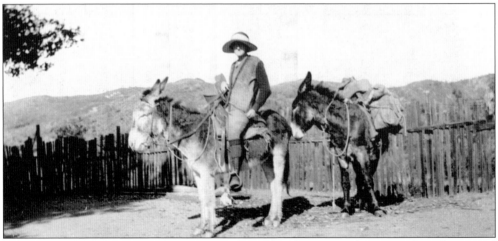

The first Monterey County librarian, Anne Hadden (1874–1963), is seen here homeward bound from Los Burros c. 1916. Hadden, born in Bandon, Ireland, immigrated to the United States in 1891. She worked at the Palo Alto Public Library, from which she was granted a leave-of-absence to help found the Kern County Free Library, and in September 1913 Hadden began working as the head of Monterey County's Free Library system. After the main library was opened in Salinas in October 1913, Hadden began setting up the branch libraries, some of which were located in remote areas. By 1919 she had established 25 branches. (Courtesy Monterey County Free Libraries, Salinas, California.)

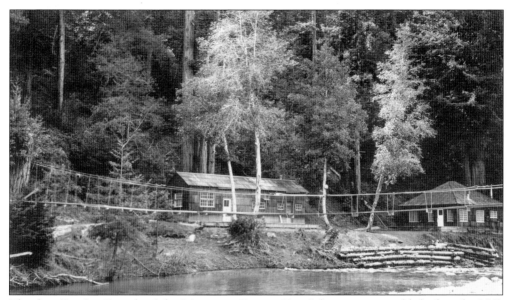

The first Big Sur Branch of the Monterey County Free Libraries was established at the U.S. Forest Service Station, then located across the Big Sur River from the entrance to present-day Pfeiffer Big Sur State Park. Elizabeth Sloane, wife of Forest Supervisor Norman H. Sloane, was the first library custodian, and held this position from November 1914 to December 1915. In those early years Hadden also established libraries at the Harlan home and at Pacific Valley School, efforts that required long trips on horseback. (Courtesy J.W. Post III.)

Mrs. S.O. Baker was the second custodian of the Big Sur Branch Library, located at "Camp Content," the home she shared with her husband, Captain Baker. She is seen here in her rose garden, located in what is now Pfeiffer Big Sur State Park. The couple's cabin was situated in a meadow known locally (and humorously) as Bakers' Field. Mrs. Baker served from December 1915 until December 1927, when she became ill and moved to Monterey. Denise Sallee, librarian and archivist working in the field of women's history, has noted, "Every branch [Anne Hadden] created became a source of social contact for its community." This was, and remains today, the case for the Big Sur Branch. (Courtesy Katherine P. Short.)

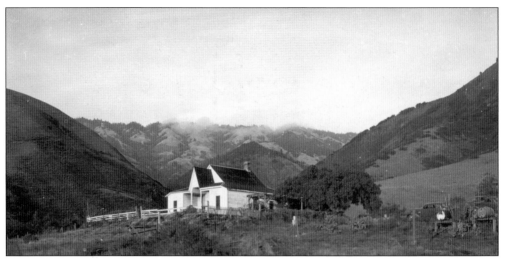

Anne Hadden also established a branch library at the home of Jasper Mansfield, seen here in a Lewis Josselyn photo from the early 1930s. The home at Pacific Valley had been the location of the Gorda Post Office from 1910 until it was discontinued in 1923, when W.R. Hearst bought the property. After that time, the home served as the residence of the local Hearst Ranch foreman; its location is now occupied by the U.S. Forest Service Pacific Valley Guard Station. Jasper Mansfield was the son of Curnell Mansfield, who came to the coast in 1864, and his wife, Mendocina, daughter of 1869 settlers William Lucas and Sarah Barnes Plaskett. (Courtesy Pat Hathaway; 71-01-BS-245.)

Pictured at the dedication of the new Big Sur Branch Library in February 1974 are, at left, Big Sur Branch librarian Katherine P. Short (1908–2001) and Monterey County librarian Barbara Wynn. Located near Ripplewood Resort in the Big Sur Valley, this building replaced the library in Mrs. Short's real estate office that had been destroyed by mudslide in 1972. During the interval, Short operated the library from her home; she served from September 2, 1958 until her retirement on January 31, 1992. Enlarged by the Friends of the Big Sur Library, with the Kaye Short Wing dedicated in 2003, the library satisfies the broad range of interests found in the Big Sur community. (Big Sur Historical Society.)

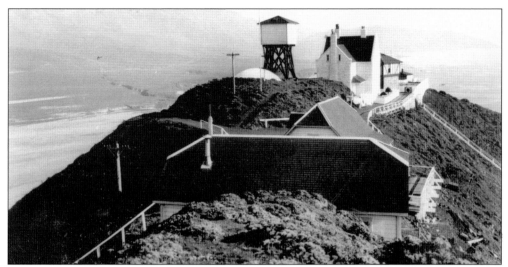

With the increase in coastwise shipping traffic during the mid–1800s, Point Sur Lightstation, seen here *c.* 1930, was a necessary improvement for navigation. Disastrous shipwrecks had occurred in the 19th century, and in 1866 the U.S. government set aside Point Sur, adjoining J.B.R. Cooper's Rancho El Sur, as a lighthouse reservation. Work began in 1887, with completion occurring on August 1, 1889. Stone for many of the structures was quarried nearby. Originally accessed via a steam-powered tramway operated by John and Joe Waters, Charles Bixby was awarded the 1899 contract to build a road to the top. Brothers Joe and Frank Post accomplished the job by the next year. (Big Sur Historical Society.)

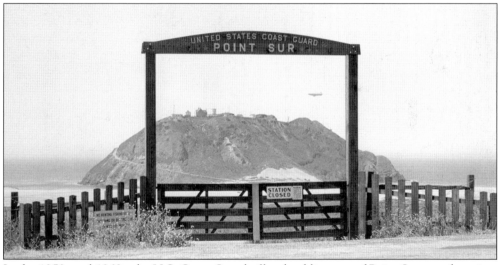

In the 1950s and 1960s, the U.S. Coast Guard offered public tours of Point Sur, seen here in a 1954 Arthur McEwen photo; the lightstation and a blimp are framed by the former entrance gate along Highway 1. On February 12, 1935, the USS *Macon*, a helium-filled dirigible, crashed into the ocean south of Point Sur with the loss of two lives. The tragedy, witnessed by the lightstation crew, signaled the end of the U.S. military's use of such aircraft. The lighthouse was automated in 1972, and the resident keepers moved away. By 1984 most of the structures had become state park property. In 1987 tours were reinstituted, with the non-profit, volunteer Central Coast Lighthouse Keepers taking charge in 1993. (Big Sur Historical Society; courtesy Alan McEwen.)

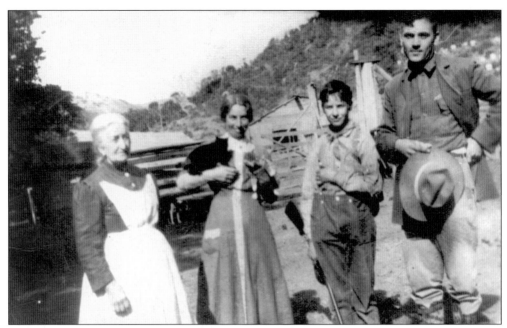

The U.S. Forest Service has maintained a presence in Big Sur since the Monterey Forest Reserve was created in 1906, predecessor of today's Monterey District of Los Padres National Forest. Seen here at the Pfeiffer Ranch in Sycamore Canyon c. 1910 are, from left to right, Barbara Pfeiffer, Julia Pfeiffer, Charles Pfeiffer (eldest son of William and Alice Pfeiffer), and Forest Supervisor Norman H. Sloane. The first Forest Service station in Big Sur was built at the Post Ranch, and by 1914 had moved to the Pfeiffer Ranch along the Big Sur River. In 1916 Sloane personally acquired 38 acres of overlooked government land along the ocean near Burns Creek. (Courtesy USDA Forest Service.)

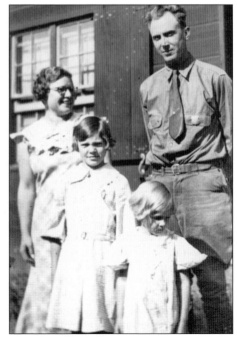

In the 1930s a new Forest Service station was built at Pfeiffer Big Sur State Park on land newly acquired from John and Florence Pfeiffer. Seen here about 1935 are the first residents of the station, from left to right, Maude (Mrs. Ralph Rhyne), daughters Loretta and Doris, and U.S. Forest Service patrolman Ralph Rhyne. The USFS station, along with the adjoining Caltrans maintenance yard, was demolished in the late 1980s; the site is now occupied by the Big Sur Multi-Agency Facility. Today, one of the major functions of the U.S. Forest Service in Big Sur is the prevention and supression of wildland fires. Ralph Rhyne grew up in Lopez Canyon in San Luis Obispo County, where his grammar school teacher was Lillian Dennis, future wife of South Coast rancher John Evans. (Courtesy USDA Forest Service.)

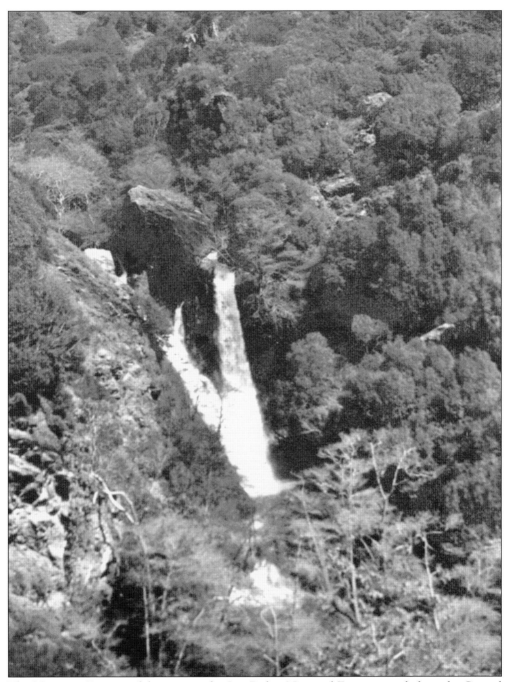

The Monterey District of the present-day Los Padres National Forest extends from the Carmel River watershed in the north to San Carpóforo Creek. Here, near the south end of the district, is Salmon Creek Falls, seen in this 1940 photo. On July 26, 1895, Benjamin Franklin Muma received government title to the land on which the falls is located. A Forest Service trail beginning at Highway 1 ascends the creek, leading to several backcountry camps within the surrounding Silver Peak Wilderness Area. Vestiges of Big Sur's gold rush days can still be found, as the area was within Los Burros Mining District. (Courtesy USDA Forest Service.)

Three Peaks straddles the Coast Ridge between Los Burros Creek to the east and the Salmon and San Carpóforo drainages to the west. In 1934 the Civilian Conservation Corps built this fire lookout station on the highest of the peaks, at 3,379 feet elevation. Photographed in September 1943, the shingled walls of the Three Peaks Aircraft Warning Service (AWS) cabin can also be seen, at the right of the picture behind the lookout building. Established during World War II, the AWS searched the skies for enemy planes and also assisted in fire-watch duties. The lookout was discontinued in 1958, and the buildings have been torn down. (Courtesy USDA Forest Service.)

Shirley Whitney is seen here on her horse Snake, c. 1943, when she was 13. Shirley's mother, Dorene Krenkel Whitney (1907–1981), a daughter of James M. and Margaret Krenkel, worked for the Forest Service as a fire lookout and aircraft spotter during World War II. Shirley's father, H.L. Whitney, had earlier served as a guard for prisoners working on Highway 1, and had also been employed on the Hearst Ranch. In 1943, during a fire in Alder Creek, Shirley worked for a week in fire camp, peeling potatoes mostly. Because of the hazardous duty pay that temporary Forest Service employees received during fires, Shirley made more money than her mother, who was on salary. (Courtesy James R. Krenkel.)

An oil tank bound for Three Peaks lookout is loaded onto two pack mules by a Forest Service crew at Salmon Creek Guard Station in 1942. Although other persons are unidentified, South Coast native Sherman Mansfield is seen at far right. Mansfield, born in Pacific Valley, was one of ten children of Curnell Henry and Mendocina Plaskett Mansfield; J.W. Post Jr. recalled Mansfield as one of the best firefighters he ever worked with. Salmon Creek Guard Station was maintained by the Forest Service at the former convict camp built during Highway 1 construction. (Courtesy USDA Forest Service.)

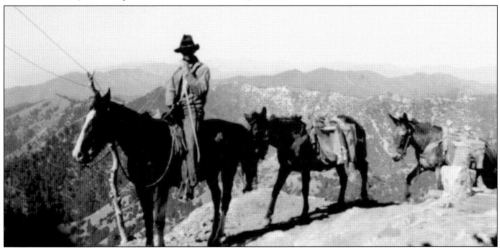

Sam Avila Sr. packs supplies to Cone Peak lookout in this photograph from 1928. Built in 1923 at the 5,155-foot summit, the structure was fitted with a flat roof in 1959, enabling the remote post to be supplied via helicopter. At the headwaters of Devils Canyon and Limekiln Creek to the west and the San Antonio River to the east, Cone Peak is within the Ventana Wilderness Area of Los Padres National Forest. Originally created in 1929 as the Ventana Wild Area, territory was added in 1978 and 1984; Cone Peak lookout is currently decommissioned. Sam Avila Sr., son of Cipriano Avila (Juan Bautista Avila's brother), was raised in the San Antonio Valley, east of Cone Peak, on the Salsipuedes Ranch of his father, Vicente. (Courtesy Monterey County Free Libraries, Salinas, California.)

During its early years, the Big Sur Grange Hall, built in 1950, was the scene of the now-legendary Potluck Revues. The 1958 Revue featured the *The Art of the Geisha*, starring, left to right, Christine Ewoldsen, Susan Porter, Gene Perrine, June Farber, and Berley Farber. This elaborate production featured costumes and sewing by Pearl Kimes, Marge Welch, Eve Miller, Edie Netland, Dorothy Lopes, Josephine Moore, Donna Deane Maynard, Gretchen McQueen, and Marty Hartman. Perrine and his partner Bob Skiles directed the early revues, originated in 1951. Celtic scholar Susan Porter was a member of the group that started the Trails Club in 1923. (Courtesy Ewoldsen family.)

In 1957 the Potluck Revue staged *The Political Rally*, a satire starring, from left to right, Fern Trotter, Fern's sister Guelda Trotter, Shirley Facha, Lynn Hettich Post, Lynn's mother Pat Hettich, Josephine Moore, Dorothy Lopes, Mary Post Fleenor, Esther Ewoldsen, Eve Miller, Shanagolden Ross, and Luneta Thelan. The Big Sur Grange was chartered in the fall of 1948 as a cooperative organization for local ranchers. For the first two years the grange met at the Pfeiffer School and at the Post Ranch; the hall was then constructed on land provided by Doris Fee. (Courtesy Ewoldsen family.)

Walter Trotter and Catherine Bengtson are seen in the 1954 production of *Ye Gods (Poses Plastiques)*. The stage manager for this comedy was Mary Post. The first meetings of the Big Sur Grange prior to the construction of the Grange Hall were held in the dining room of Rancho Sierra Mar, the restaurant operated by Mary on the Post Ranch property adjoining Highway 1. Catherine Bengtson, a neighbor of the Posts, was a long-time resident of Coastlands. The Potluck Revue, produced and directed with local volunteer expertise, began as a fundraiser for the grange. (Courtesy Ewoldsen family.)

The 1954 Big Sur Potluck Revue also included the sketch *A Pretty Girl Is Like A Melody*, and starred, left to right, J.W. (Bill) Post III, Walter Trotter, Bob Skiles, Franklin Peace, and George Kafka. Franklin Peace, a second cousin of Bill Post's, is the son of Ellen and Robert Peace and the great-grandson of pioneer William Brainard Post. Peace lived on the coast for many years and now resides in Carmel Valley with his wife, Ruth. Since 1955 the grange has published a monthly newsletter, the "Big Sur Round-up," now under the longtime editorship of Bette Sommerville. (Courtesy Ewoldsen family.)

The Big Sur Historical Society (BSHS) was founded in 1978, with the mission of preserving and interpreting the history of the coast. In 1979, locals celebrated the Fourth of July with a parade along Highway 1 in the Big Sur Valley. Seen here are Hans and Esther Ewoldsen, who rode on the BSHS float that year. BSHS dedicated its Molera Ranch House Museum, operated in partnership with California State Parks, in June 1999 at Andrew Molera State Park. The facility is housed in the historic foreman's residence, built more than a century ago. BSHS also maintains the Bill and Luci Post Archives at Post Ranch Inn. (Courtesy Ewoldsen family.)

Each October, the South Coast hosts its Jade Festival at Pacific Valley School. In 2000, artist Richard Horan displayed his jade jewelry and carvings. The South Coast Community Land Trust (SCCLT) originated the festival. Founded in 1991, the SCCLT's mission is to further the needs of South Coast residents, with the special goal of establishing a community center. The three-day Jade Festival features some 45 booths offering unique, handcrafted items—especially those made from jade, a precious stone found locally. Horan and his wife, Peggy, have lived at the former Gregory Bateson place on Gorda Mountain since 1981. Richard originally came to live in Big Sur in 1965. (Courtesy Richard Horan.)

Shown at the dedication of the Big Sur Health Center, from left to right, are County Supervisor (now U.S. Congressman) Sam Farr, Katherine P. Short, Kathy Penebre, Dr. Saul Kunitz, and Ray Sanborn. The clinic, which opened on September 26, 1979, was first located at the Big Sur Grange Hall. Open five days each week, the facility now provides "comprehensive health care to all in Big Sur, regardless of ability to pay." The original operating expenses came from the County of Monterey, Esalen Institute, and private citizens; today, half its expenses come from fund-raising. The Big Sur Health Center opened its present clinic, near River Inn, in November 1985. (Courtesy Carmel *Pine Cone* and Jaci Pappas.)

Seen here, from left to right, the first three Local Resident Representatives of the Big Sur Multi-Agency Advisory Committee are Barbara Woyt, Katherine P. Short, and Ken Wright. BSMAAC was formed in 1986; the first meeting, held on October 29 of that year, was chaired by U.S. Congressman Leon Panetta, later President Bill Clinton's chief of staff. Comprised of representatives of government agencies with land stewardship roles in Big Sur as well as members of local citizen groups, BSMAAC meets quarterly to discuss problems shared by the community. Its primary objective is to assure that consistency with county planning standards is maintained by BSMAAC members. (Author's collection.)

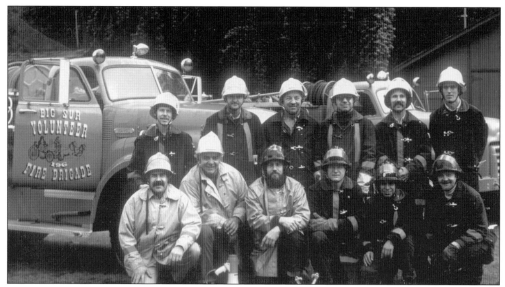

The Big Sur Volunteer Fire Brigade was organized in August 1974. Seen here in 1976, from left to right, are (front row) Pat Chamberlain, Chief Walt Trotter, Frank Pinney, Peter Stock, Julian Lopez, and Gary Koeppel; (back row) Robbie Warcken, Gady Colvin, Frank Trotter, Phil Fish, Steve Wagy, and Ray Sanborn. The South Coast company of the brigade was started in 1985, with members Erik Jensen, Sandy Sanderson, Ken Comello, Jim Kimball, Tom Brenner, Lincoln Curtis, David Harris, Kate Stock, Ken McLeod, and John Corley. In addition to responding to fires and vehicle accidents, the brigade offers emergency medical care and "high-angle" cliff rescue. (Courtesy Big Sur Volunteer Fire Brigade.)

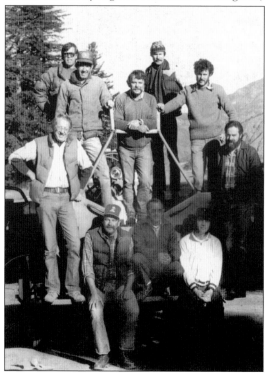

Established in April 1979, the Mid-Coast Fire Brigade is based in Palo Colorado Canyon. When their first engine was acquired in December 1978, these members met for a picture at the Glen Deven Ranch of Virginia and Seeley Mudd. From left to right are (seated) Bob Douglas, Lee Falkenberg, and Larry Snow; (front row standing) Ron Cook and Jim Cox; (middle row) Norm Cotton, Patrick Allen, and Craig Craven; (back row) Brian Morton and Allan Lewis. (Courtesy Jim Cox.)